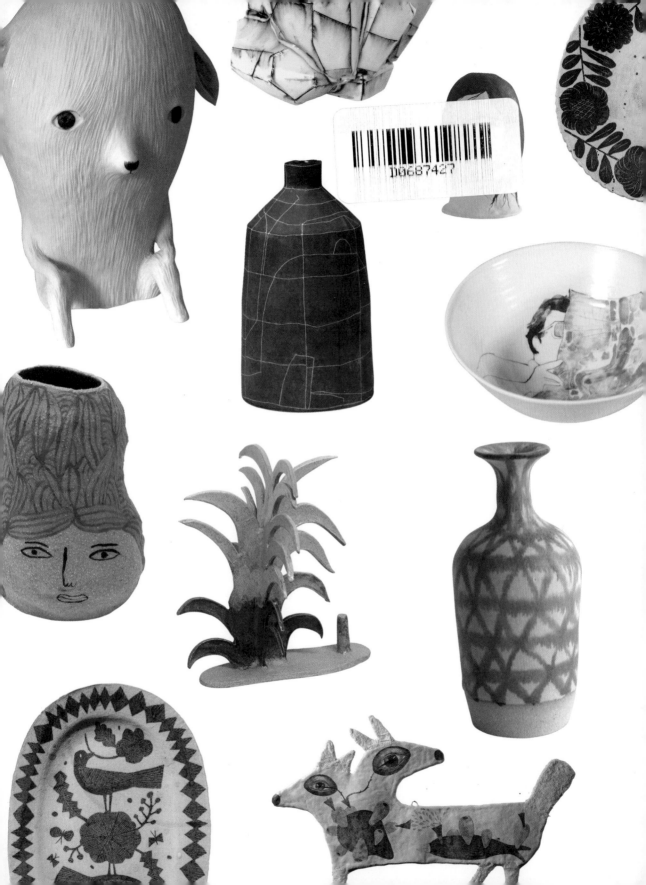

CERAMICS

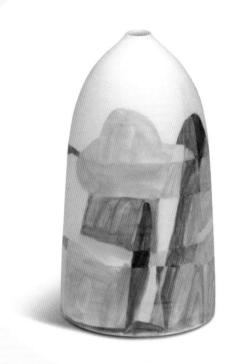
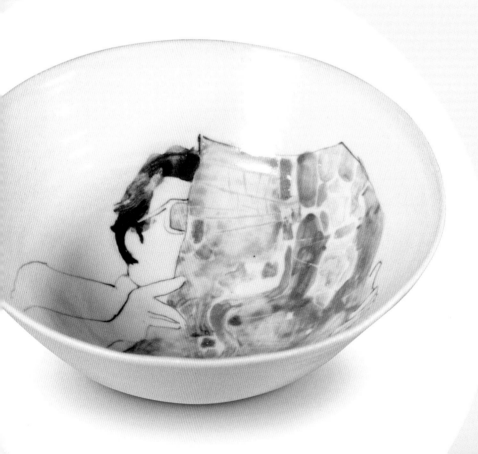

CERAMICS

CONTEMPORARY ARTISTS WORKING IN CLAY

By Kate Singleton

Foreword by Danielle Krysa

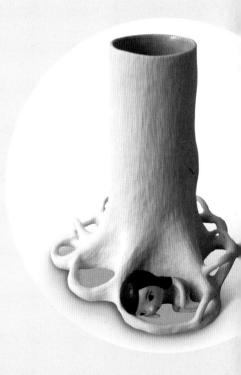

CHRONICLE BOOKS

SAN FRANCISCO

PAGES 174–176 CONSTITUTE A CONTINUATION OF THE
COPYRIGHT PAGE.

LIBRARY OF CONGRESS CATALOGING-IN-PUBLICATION DATA:

NAMES: SINGLETON, KATE (KATE J.), 1983- AUTHOR. |
 KRYSA, DANIELLE, WRITER OF FOREWORD.
TITLE: CERAMICS : CONTEMPORARY ARTISTS WORKING IN CLAY /
 BY KATE SINGLETON ; FOREWORD BY DANIELLE KRYSA.
DESCRIPTION: SAN FRANCISCO : CHRONICLE BOOKS, 2016.
IDENTIFIERS: LCCN 2015037471 | ISBN 9781452148090
SUBJECTS: LCSH: ART POTTERY—21ST CENTURY—THEMES, MOTIVES. |
 CERAMIC SCULPTURE—21ST CENTURY—THEMES, MOTIVES.
CLASSIFICATION: LCC NK3940 .S56 2016 | DDC 730.1—DC23 LC
 RECORD AVAILABLE AT HTTP://LCCN.LOC.GOV/2015037471

MANUFACTURED IN CHINA

DESIGN BY SARA SCHNEIDER

ARTWORK PAGE 2 BY TANIA ROLLOND AND JULIA HUTEAU
ARTWORK PAGE 3 BY NATHALIE CHOUX

10 9 8 7 6 5 4 3 2 1

CHRONICLE BOOKS LLC
680 SECOND STREET
SAN FRANCISCO, CALIFORNIA 94107

WWW.CHRONICLEBOOKS.COM

To my grandmothers, Betty and Joanne,
for passing down their love for art.

CONTENTS

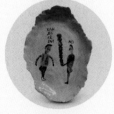
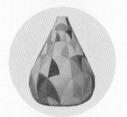

FOREWORD

BY DANIELLE KRYSA

What comes to mind when you think of ceramics? Wobbly mugs and crooked bowls that you made at summer camp? A few years ago, that's probably exactly where my thoughts would have gone. However, after writing a contemporary art blog for years, my eyes have been opened to so much more. Now, to be totally clear, I've never actually worked in ceramics myself—well, unless you count the wonky ashtray that I made as a Girl Scout, circa 1979 (yes, they taught children to make ashtrays—it was a different time). That said, even though I haven't personally mastered this particular art form, I do have a small—all right, fairly huge—obsession when it comes to contemporary ceramics. There is something very special about work that beautifully, and seamlessly, blurs the line between fine art and craft.

Ah, yes, art or craft—that is such an interesting topic, and ceramics are right in the middle of that discussion. Honestly, this conversation always hurts my head a little bit. What makes something art versus craft? Intent? Venue? Scale? Volume? Price? Marketing? Ouch, there's that headache again. For me, the wonderful thing about ceramics in particular is that it allows artists to use a traditional medium to create functional pieces, fine art pieces, and an exciting combination of the two. (You can't say that about painting—unless of course you try serving dinner on a canvas.)

In recent years, there seems to be a movement happening in the art world—work that used to be traditionally thought of as "craft" is making its way onto the white walls of galleries and museums all over the world. Embroidery, crochet, and yes, ceramics. It thrills me every time I see this kind of work pop up in shows, and in writing this foreword, I had to stop and truly think about why

I am so drawn to this craft-turned-art type of work. Perhaps there is comfort and familiarity in everyday materials like thread and clay—and then, in the hands of the right artists, those familiar materials are elevated to new artistic heights. I've talked to so many people who say they're intimidated by "the art world"—that it's a place reserved for other people—and these are people who study, collect, or make art every day. And maybe that's why fine art that is rooted in a craft background feels more accessible to a larger audience. It might not be your wonky ashtray, but you can recognize ceramics as being part of your day-to-day world, functional yet artistic, allowing you to not only live with art in your home but to actually use it as well.

As this art/craft line continues to blur even more, we're beginning to see a new crop of ceramic artists emerging—often trained in other disciplines—who just view clay as yet another material to add to their creative toolbox. An idea might be expressed best using paint, or photography, or perhaps the tactile, form-shaping properties of clay will be the most clever way to share the story. Illustrators are taking drawings from the page and reimagining them into three-dimensional forms, sharing their ideas in an entirely new way. Painters can exchange canvas for clay slabs, and photographers are able to transfer their images onto objects, changing their work dramatically.

All of the beautifully curated work by the very talented artists in this book pushes clay to new places, no longer for the cupboard alone: these artists have taken ceramics from the kitchen counter to the gallery wall.

INTRODUCTION

Ceramics has sparked the imagination of a new generation of artists who are redefining this previously overlooked art form. What was considered a quiet, traditional art practice has been reinvigorated by these artists' creative energy and cross-media experimentation. The stunning ceramics that have come out of this resurgence have not gone unnoticed, and you are likely to see ceramics regularly featured in art blogs and glossy magazines, and handsomely displayed in galleries and design outposts. While some artists featured in this book have devoted themselves entirely to ceramics, many others have multifaceted practices that overlap in areas such as illustration, drawing, and painting. Despite differences in style, background, and geography, the ceramicists featured in the following pages cite the same fundamental reasons for working in clay: its intimate process, versatility as a medium, and rich history. Above all, they choose to work with clay to create art that transcends the canvas or sheet of paper and exists in the three-dimensional, physical, tactile world.

For decades material-based art forms like ceramics were marginalized, downgraded to the category of craft. Many dedicated and distinguished potters continued making exceptional work, but on the whole, ceramics made few waves in the conversation on new art and visual culture. Then, in 2003, renowned British potter Grayson Perry won the Turner Prize, and ceramics was thrust into the spotlight of the international art scene. Perry stated that at that time, pottery was "seen as a second-class thing" in relation to more prestigious art forms such as painting and sculpture. In the years since his historic win, the distinction between fine art and craft has crumbled, and a new era of creativity in ceramics has

arrived. Today ceramics has emerged as a mainstream and highly relevant contemporary art form. As writer Lily Wei humorously put it in *Art News,* "Ceramic art . . . has finally come out of the closet."

The renewed interest in ceramics is not an isolated phenomenon but part of a larger cultural shift towards handmade and local goods. In our fast-paced, technology-driven lives there is a yearning for more personal experiences and exchanges. We seek out handmade and one-of-a-kind objects because they are reminders of our innate connection to each other and to the world—something we easily lose sight of in our day-to-day lives. As Minnesota-based artist Brett Freund states, "Ceramic objects are personal objects for both the maker and the admirer." The primitive interaction between maker, object, and user goes back tens of thousands of years and yet still holds meaning in today's postindustrial economy.

What sets ceramics apart is the fact that it is art that we can hold in our hands and use in our daily lives. As children we learn to suppress the compulsion of touching everything we set sight on, but the desire to touch, and the joy that comes from touch, are ever present. The simple act of picking up a ceramic object is an experience of the senses, with the surprise of weight and texture, and how it feels in the hand. Ceramic art is rooted in ordinary life, to the dishware, teapots, and vases we use every day. It thereby provides a personal and grounding experience even to those who are wary of contemporary art. Since we all have experiences with these objects, we already have context for understanding ceramic art.

Clay offers artists who might otherwise work on canvas or paper a way to bring their artwork into the three-dimensional world. There are significant parallels between ceramics and painting; in both practices artists alter a surface with color and marks. A number of the artists featured in this book see themselves as painters of

clay. For example, Rebekah Miles of California describes herself as "primarily a painter using clay as my 'canvas.'" However, clay can be more than just a surface to cover. Whereas an artist painting on canvas is limited to modifications made to the two-dimensional surface, ceramic objects are formed by the artist from a mound of wet clay. It is easy to understand how artists are drawn to the possibilities of clay, to its malleability and physicality. The artist transforms the raw material into an object all its own, with seemingly limitless possibilities of form, use, and decoration. Furthermore, there are endless different techniques, types of clay, glazes, and kilns that can take a lifetime to explore. It is a process and experience that draws many artists from other fields. New York– and London–based Kaye Blegvad states, "I am primarily an illustrator, but I got hooked on the hands-on process . . . of ceramics, which has since become an important part of my work. I love being able to combine drawn and three-dimensional elements."

Among art school students and recent graduates, a growing number of talented illustrators, painters, and sculptors are throwing themselves into ceramics. Thanks in part to these enthusiastic young artists, the gap between ceramics and traditional art practices is diminishing. As Norwegian artist Kjersti Johanne Barli explains, "I work in different media, but ceramics stands out because of its tactility. It is of great value to me to work more physically with my hands—to shape and create something other than on a piece of paper." Australian Tania Rollond reveals her passion for clay: "I love the challenge of working in both two and three dimensions, and remain hopelessly addicted to the transformation that happens in kilns."

We are witnessing not just a rise in the popularity of ceramics, but a creative boom, as many artists turn to clay to fulfill great imaginative visions and communicate important messages. Today's artists are redefining ceramics as a medium that will at various

times make you laugh, cry, smile, or cringe. Romanian duo Ildiko Muresan and Flavia Marele describe their surreal works in clay as "fragments of our souls" that reflect a world "where everything is possible." Artists are putting convention aside and approaching ceramics with a newness and sense of possibility. The ceramic creatures of French artist Nathalie Choux are full of the brightness of innocence and appear to have magically walked off an animated screen. Spanish artist Laura Lasheras has a truly unique vision. Her sculpture XXXX (2014) is made of a soft textile body adorned with pointed ceramic horns. With works like these, one's sense of materiality is turned upside down, and the artist's choice of material becomes a big part of the conversation. Ceramicists are also addressing meatier topics in their work. Kjersti Johanne Barli reimagines the seven deadly sins with humor: The Bowl of Gluttony (2013) features portly male figures in outline, bellies full of hamburgers. Australian Stephen Bird is well known for challenging conventions in his ceramics, as he does in Tennis (2010), which depicts two Jesus figures playing a leisurely game of tennis. In his masterful ceramics, Thai-born Australian artist Vipoo Srivilasa invokes difficult questions about migration and the culture of place and identity.

The artists in this book are upping the ante and challenging our most basic assumptions about what can be done in clay. These contemporary ceramicists infuse their ceramics practice with their own particular artistic vision, borrowing themes and modes of expression from practices in illustration, painting, collage, and sculpture. They are expressing ideas and feelings in clay that we typically associate with painting and other forms of art. They approach the medium in different ways: some are traditionally trained, longtime potters; others are painters, illustrators, or sculptors who have taken up the medium on their own terms. What makes all of their work reach beyond the domain of craft is a commitment to their own full-fledged artistic vision.

CHAPTER 1: NARRATIVE

Illustration and storytelling in ceramics

The artists in this chapter, many of whom are illustrators, utilize the surface of their ceramic objects to depict people and things, and to tell stories.

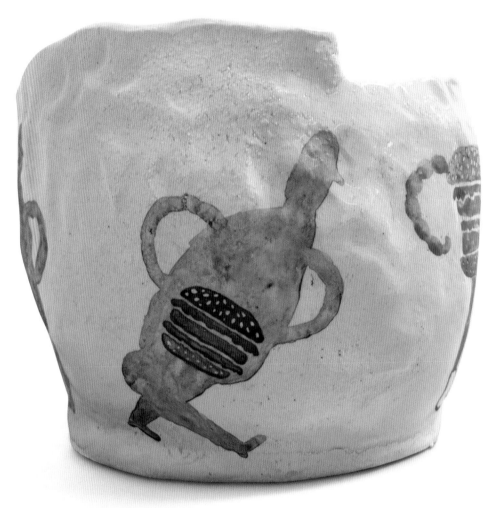

The Bowl of Gluttony, 2013
Stoneware clay

KJERSTI
JOHANNE BARLI

BORN

Norway, 1987

CURRENT LOCATION

Oslo, Norway
www.kjerstibarli.com

BIOGRAPHY

At age eighteen, Kjersti Johanne Barli moved from her home in the country-
side to study illustration in Trondheim, Norway. She continued her studies
at the Oslo National Academy of the Arts. Today she is a freelance illustra-
tor and artist who has worked on commissions for newspapers, magazines,
books, and children's books. Barli has exhibited her drawings, paintings,
collages, and ceramics in Oslo and Prague. In 2014 she was one of thirty
artists nominated for the Young Illustrators Award in Berlin.

ARTIST STATEMENT

*I work in different media, but ceramics stands out because of its tactility. It is of
great value to me to work more physically with my hands—to shape and create
something other than on a piece of paper. It has added great value to my drawing
style as well; I'm transferring ways of forming body parts to my drawings. With
clay, things rarely turn out exactly as planned, and suddenly I have a new, fun
shape that I can bring with me into the drawing world. It was fun to observe that
this goes both ways—I kind of already had a style of shaping clay as soon as I
started working with it.*

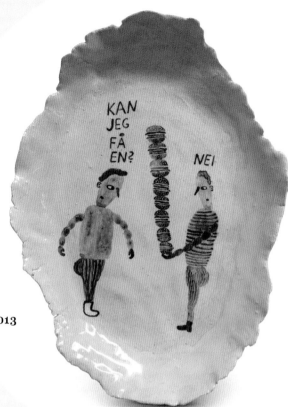

The Plate of Greed, 2013
Stoneware clay

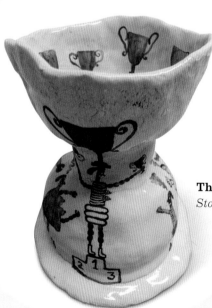

The Goblet of Envy, 2013
Stoneware clay

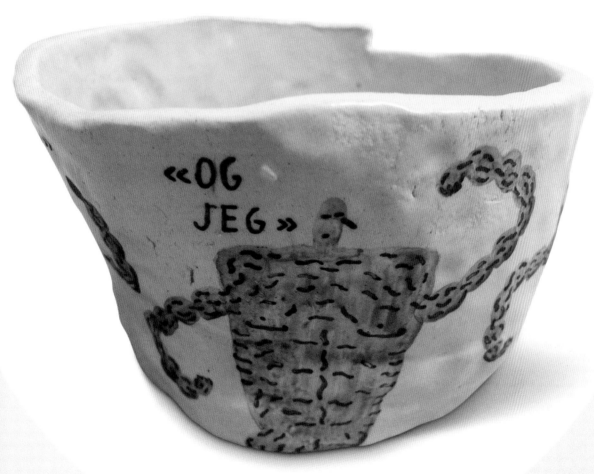

The Bowl of Pride, 2013
Stoneware clay

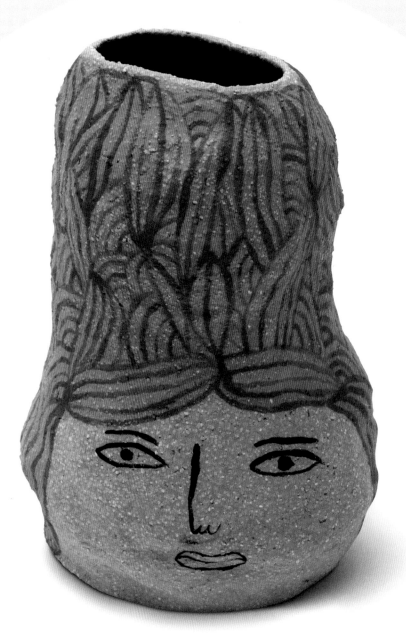

Red Head Face, 2013

Stoneware, colored slip, underglazes, oxides, and glazes

LAURA BIRD

BORN

South Wales, United Kingdom, 1986

CURRENT LOCATION

London, England
www.laurabird.co.uk
www.etsy.com/shop/lauralaurabird

BIOGRAPHY

Laura Bird is an illustrator and ceramicist living and working in East London. In 2009 she graduated from Kingston University with a Bachelor of Arts in Illustration. During her final year at university, her end-of-year project was created from mixed media with clay elements. Since then she has worked in ceramics and, through evening courses and experimentation, developed her own quirky touch. Bird's ceramics have been featured online in publications including Booooooom and It's Nice That. She is also part of the film collective This Is It.

ARTIST STATEMENT

My work in ceramics is very playful. The pieces retain a naïve quality in the decoration and also in the way they are constructed, with finger marks visible and a unique wobbliness! I experimented in many different areas before discovering ceramics. I love drawing and painting, and feel much more comfortable applying these practices to a three-dimensional piece whether it be in wood, textiles, or paper. Ceramics is such an amazing medium to work in, as it is so vast—there are so many techniques, you could never learn them all!

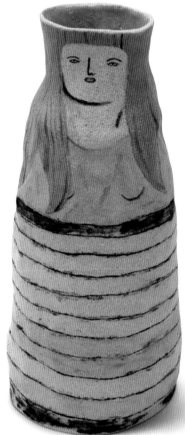

Red Head, 2013
Stoneware, colored slip, underglazes, oxides, and glazes

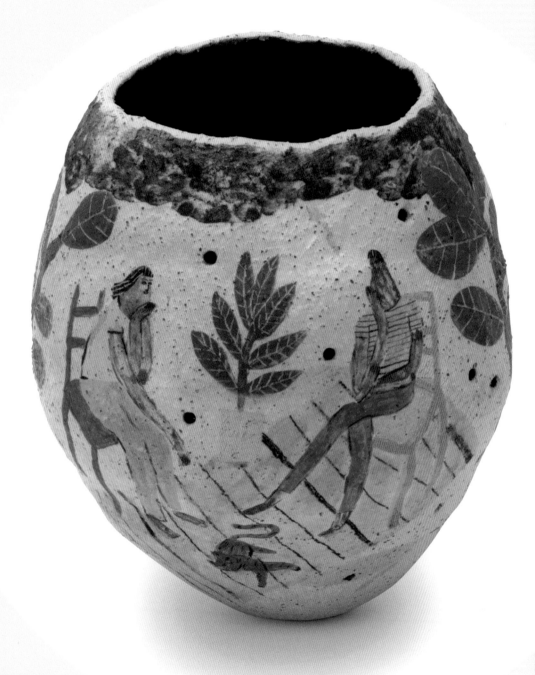

Chat, 2013
Stoneware, colored slip, underglazes, oxides, and glazes

LAURA BIRD

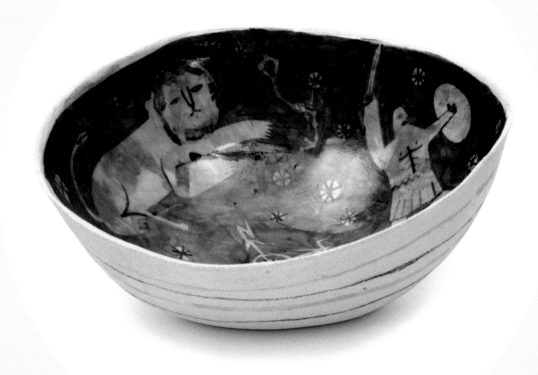

Galaxy, 2013
Stoneware, colored slip, underglazes, oxides, and glazes

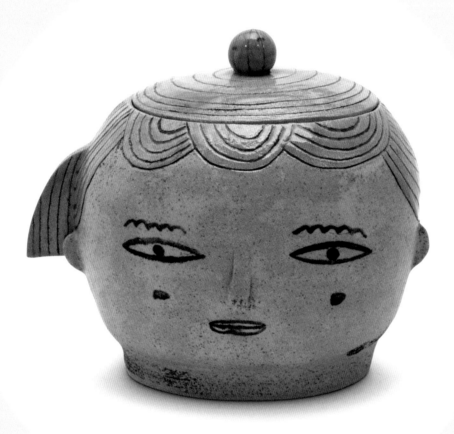

Bun, **2015**
Stoneware, colored slip, underglazes, oxides, and glazes

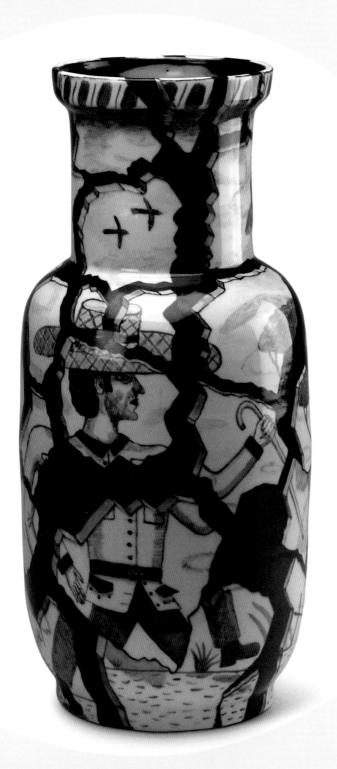

Shattered Vase, 2013
Clay, pigment, and glaze

STEPHEN BIRD

BORN

Stoke-on-Trent, England, 1964

CURRENT LOCATION

Sydney, Australia
www.stephenbird.net

BIOGRAPHY

Stephen Bird studied Fine Art at Duncan of Jordanstone College of Art and Design in Dundee, Scotland, and completed postgraduate studies at Cyprus College of Art. Bird initially trained as a painter, but has been working in ceramics and sculpture since the early 1990s. He has exhibited extensively throughout the United Kingdom, Australia, and the United States, and his work is held in many public collections, including those of the National Museum of Scotland, National Museums Northern Ireland, and National Gallery of Australia. Bird was featured in *Contemporary Ceramics* (2009) by Emmanuel Cooper. He lectures at the National Art School, Sydney.

ARTIST STATEMENT

My ceramic works locate themselves in an invented world where dissonant cultural idioms come together to form a language or style I have coined Industrial Sabotage. As a way of positioning my art within the increasingly deterritorialized world, I have, in my imagination, returned to the heritage of my place of origin in North Staffordshire, and reinterpreted the tradition of mass-produced ornamental ceramics made there in the eighteenth and nineteenth centuries. With this as a starting point, I use humor propaganda, trompe l'oeil, and meaningless violence to retell archetypal myths and make observations about complex collective issues, including politics, cultural imperialism, and the global power struggle.

Old China, 2009
Clay, pigment, and glaze

Tennis, 2010
Tin-glazed earthenware

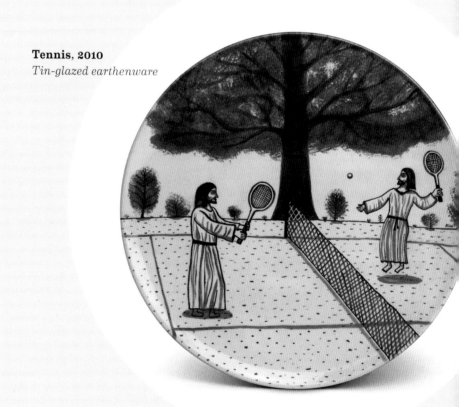

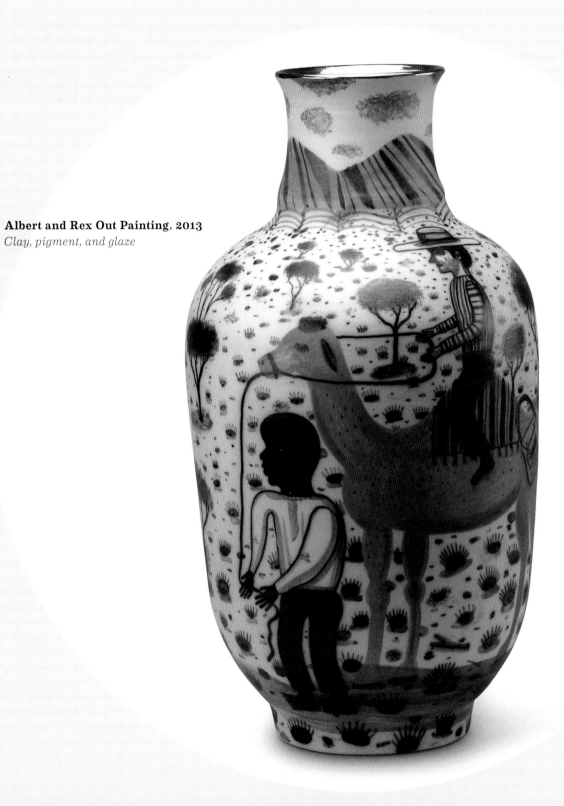

Albert and Rex Out Painting, 2013
Clay, pigment, and glaze

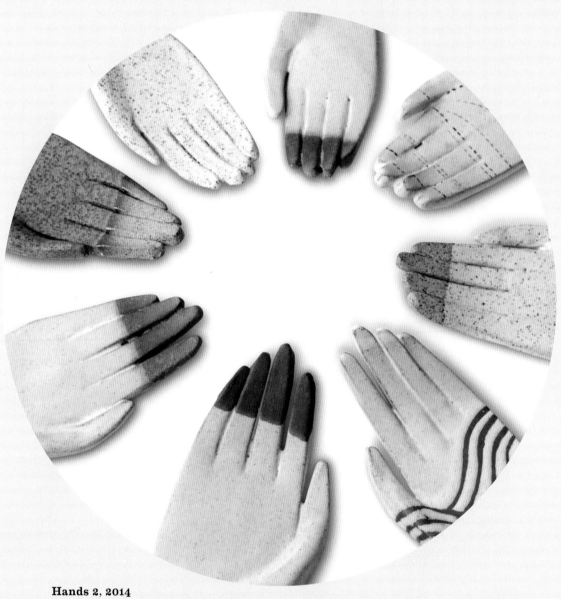

Hands 2, 2014
Stoneware, glaze, and oxides

KAYE BLEGVAD

BORN

London, England, 1987

CURRENT LOCATION

Brooklyn, New York
www.kayeblegvad.com
www.etsy.com/shop/kayeblegvad

BIOGRAPHY

Kaye Blegvad is an illustrator, designer, and general maker. She was born and raised in London, studied illustration at the University of Brighton, and since then shares her time between London and Brooklyn.

ARTIST STATEMENT

I am primarily an illustrator, but I got hooked on the hands-on process and unpredictability of ceramics, which has since become an important part of my work. I love being able to combine drawn and three-dimensional elements, hand-building the form—sometimes very crude and abstract—and then drawing detail on top of it, giving it features that allow you to read the shape. I make a mixture of functional and decorative pieces, and the motifs I use are often repeated—hands, heads, figures—though their execution always differs. I work across many different media, but there's something very tangible, very "real" about ceramics. I enjoy physically working with the clay, I enjoy the unpredictability of the results, and I enjoy how solid and permanent the final pieces feel.

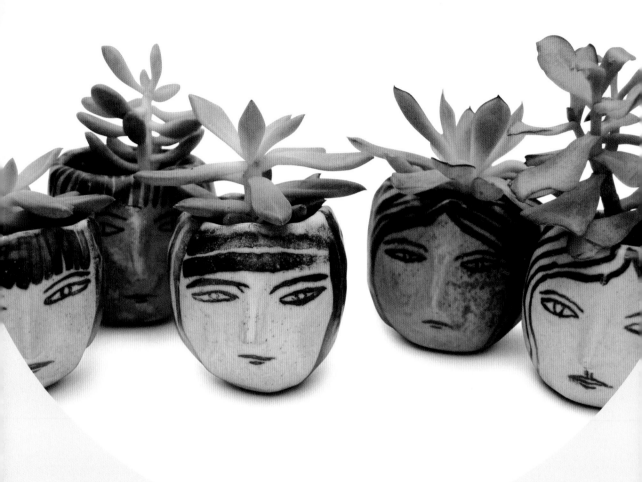

Girls Head Planters, 2014
Stoneware, glaze, and oxides

Reclining Nude, 2014
Stoneware, glaze, and oxides

Lady Vase, 2014
Stoneware, glaze, and oxides

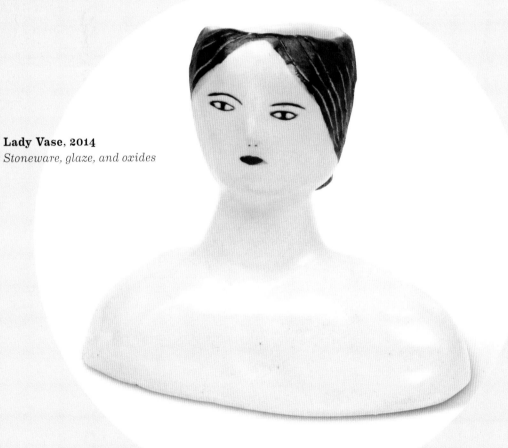

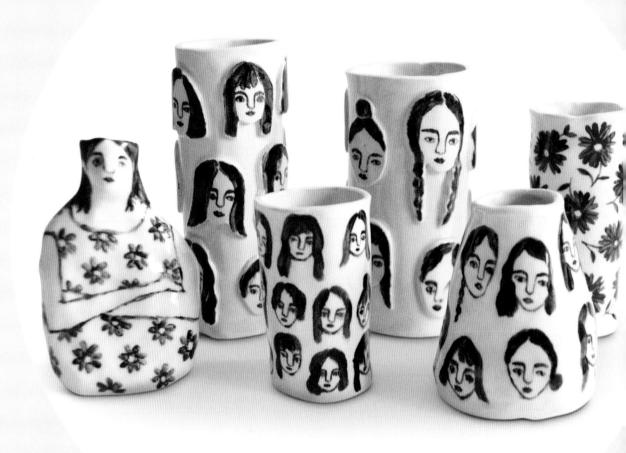

3D Girls Vase, 2014
Stoneware

LEAH REENA GOREN

BORN

La Jolla, California, 1988

CURRENT LOCATION

Brooklyn, New York
www.leahgoren.com
shop.leahgoren.com

BIOGRAPHY

Leah Reena Goren is an illustrator and surface-pattern designer living in Brooklyn, New York. She graduated from Parsons School of Design in 2012 with a Bachelor of Fine Arts in Illustration. Goren works on projects ranging from packaging to bedding to books for clients including Anthropologie, the Land of Nod, and Chronicle Books, and also runs a web-shop selling her own products.

ARTIST STATEMENT

I like ceramics because it's a nice break from my commercial work but still a creative way to extend my illustration. I often paint my ceramic pieces with motifs I've been trying out in my sketchbook; sometimes it flips, and my ceramics inspire my other work. I also love how tactile clay is, and the end piece is a finished product that feels more real than just a drawing on a page. I started working in ceramics about three years ago with my mom, an artist who has a kiln, in California, and then began working in studios in New York City.

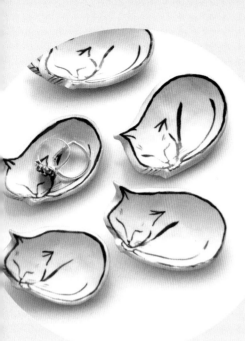

Mini Cat Ring Dishes, 2014
Stoneware

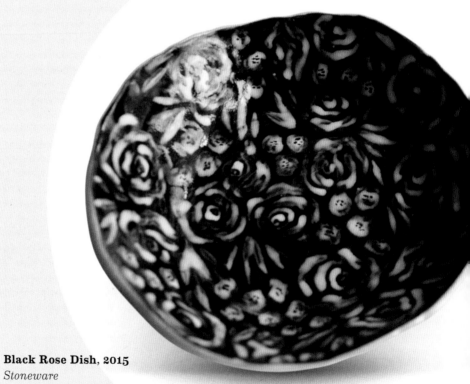

Black Rose Dish, 2015
Stoneware

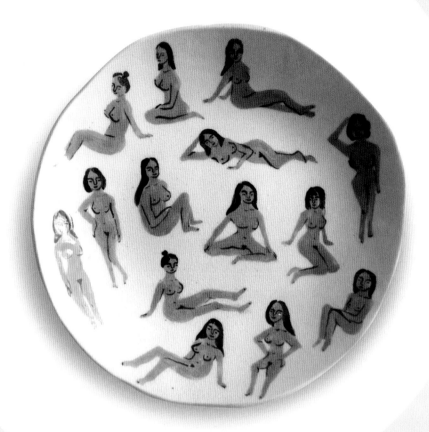

Naked Ladies Dishes, 2014
Stoneware

LEAH REENA GOREN

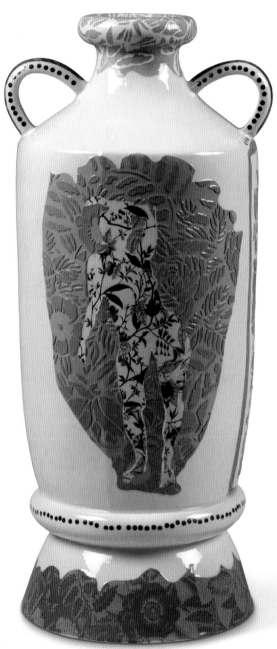

Filigree Apricot, 2009
Color slip, hand-cut enamel transfer on earthenware

CHARLOTTE HODES

BORN

London, England, 1959

CURRENT LOCATION

London, England
www.charlottehodes.com

BIOGRAPHY

Charlotte Hodes studied at Brighton College of Art and at the Slade School of Fine Art–University College London, where she completed her Bachelor of Arts in Fine Art and Master of Arts in Painting. She exhibited at the Venice Biennial in 2009 and 2013, and has had solo shows at the Wallace Collection (London) in 2007 and Marlborough Gallery (New York) in 2009. In addition, Hodes has exhibited in group shows at the Design Museum (London) in 2003 and at the Victoria and Albert Museum (London) in 2002. She is a professor in Fine Art at the London College of Fashion–University of the Arts London.

ARTIST STATEMENT

My experience as a painter influences my ceramics and my large-scale paper cuts, which have been both digitally collaged and intricately hand-cut and inform my ornately decorated ceramic vessels. My iconography is centered on the female figure within a contemporary context, depicted as a silhouette juxtaposed with motifs loaded with references associated with the female, such as the vessel, the dress, and the domestic.

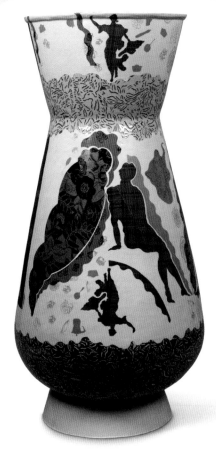

Filigree on Green, 2009
*Color slip, hand-cut enamel transfer
on earthenware*

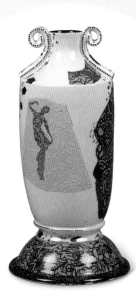

Filigree Gold; Icons, 2009
*Color slip, hand-cut enamel transfer
on earthenware*

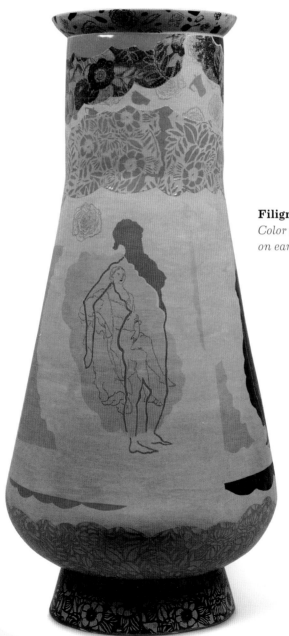

Filigree; Blue, 2009
Color slip, hand-cut enamel transfer on earthenware

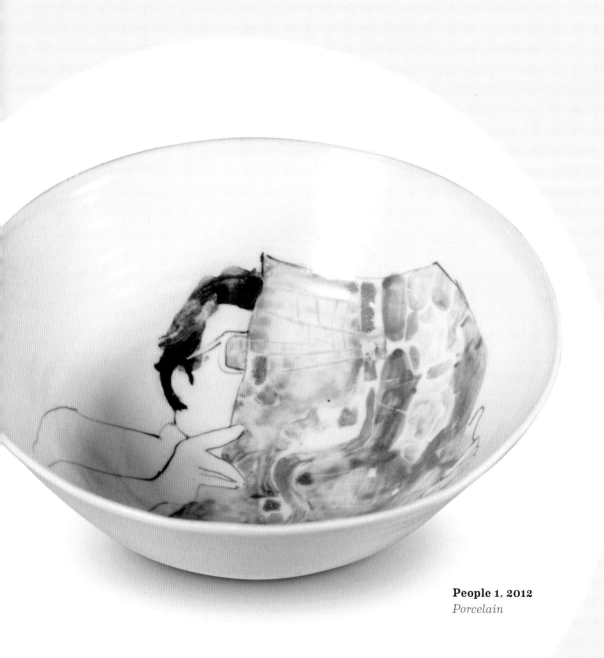

People 1, 2012
Porcelain

JULIA HUTEAU

BORN

Léhon, France, 1982

CURRENT LOCATION

Dieulefit, France
juliahuteau.free.fr

BIOGRAPHY

Julia Huteau was born in Léhon, France, and started drawing at a young age. At the age of sixteen she traveled to Tamba, Japan, to study primitive ceramics. In 2007 she opened her first ceramics studio in her native France, and in 2012 she was an artist in residence in Shigaraki, Japan. Today her studio is in an old earthenware factory in Dieulefit, a town in the South of France famous for its ceramics.

ARTIST STATEMENT

In the beginning my choice of working in ceramics was instinctive, but today the decision seems well thought out and sober-minded. I am glad to be involved in the discipline of ceramics in its totality, and manage to put aside my personal tastes so I can view and understand the works in terms of shape, materials, graphics, and historical references. The drawings on some of my works add an acute consciousness of volume and space. Today my research goes back to the starting point, turning raw materials into objects that take up physical space.

People 2, 2012
Porcelain

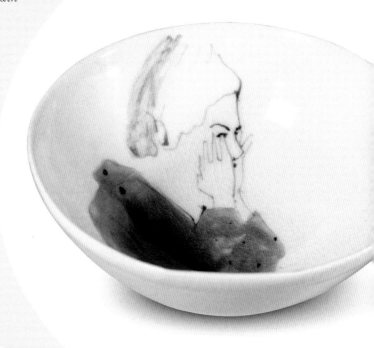

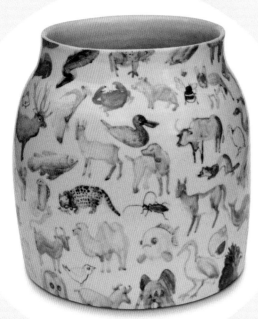

1000 Animals, 2013
Porcelain

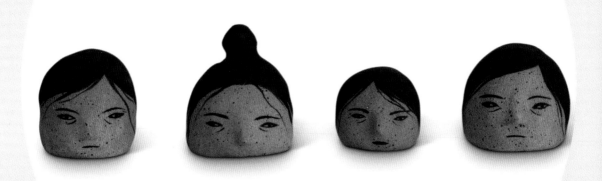

Untitled 2 (Heads), 2015
Red-brown clay, paint

RAMI KIM

BORN

Seoul, Korea, 1981

CURRENT LOCATION

Los Angeles, California
www.ramiskim.com

BIOGRAPHY

Rami Kim (also known as Ramis) is an artist, maker, and award-winning animator. With her background in animation, she creates works in clay that are whimsical and poetic. She loves working with puppets, paper, watercolor, gouache, and lastly, clay, which has led her to a whole new adventure. She lives and works in Los Angeles and enjoys the creative process of making art.

ARTIST STATEMENT

My practice with ceramics has been mainly centered on making heads, faces, and figurines of imaginary characters. I am interested in expressing the human form, mostly heads, through ceramics, because I see the heads as individual characters—identities—and I believe they are powerful and beautiful. I approach my work as being an art object rather than just a dish to hold food. I like people finding interesting moments while using the pieces, or looking at them.

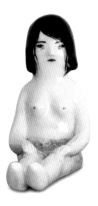

Girl, 2014
Porcelain, paint

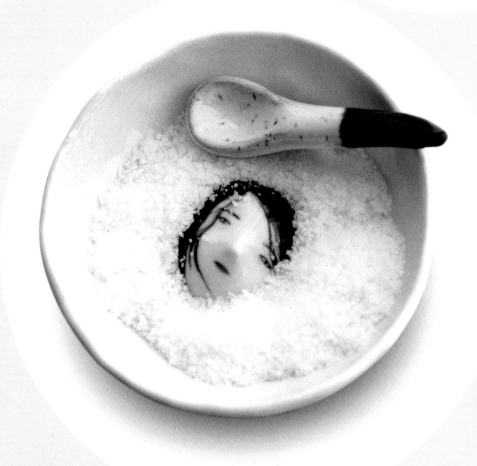

Buried Under the Snow, 2014
Porcelain, paint

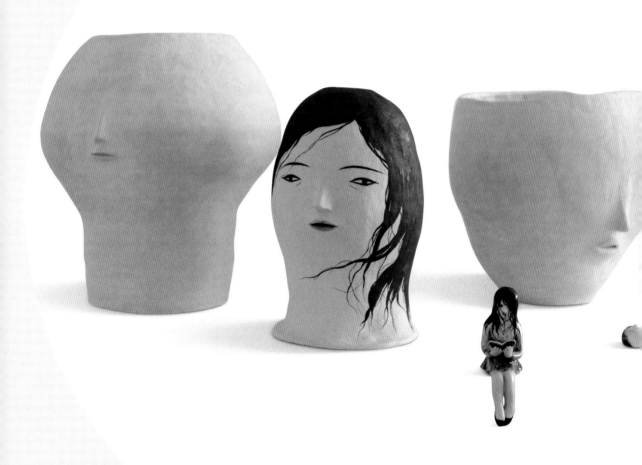

Two Face Vessels and Untitled, 2015

Paperclay, painted stoneware

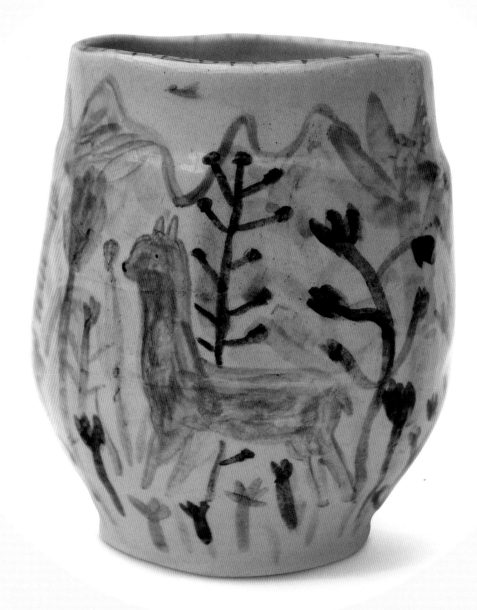

Alpaca 1, 2014
Ceramic

ALEX SICKLING

BORN

Newcastle, England, 1990

CURRENT LOCATION

Newcastle, England
www.alexsickling.co.uk
www.etsy.com/uk/shop/alexsickling

BIOGRAPHY

Alex Sickling is an image-maker, illustrator, and ceramicist based in Newcastle-upon-Tyne. Since graduating from Leeds College of Art in 2012, Sickling has worked with clients such as Anthropologie, unique & unity, The Shop Floor Project, and Plum & Ashby, as well as taking part in group and solo shows in the United Kingdom.

ARTIST STATEMENT

I am exploring the process of image-making and illustration through ceramics, creating both functional and decorative one-off pieces. I am often inspired by my passions for folk art, the Northumbrian countryside, and David Hockney, and a love of Scandinavia. As an image-maker, I was not very comfortable working on paper. I found something in working with ceramics that gave me the results I was looking for. I enjoy the challenge of working from a basic sketch and then trying to reflect that as a tangible object, pushing the boundaries of both image-making and the materials I'm using.

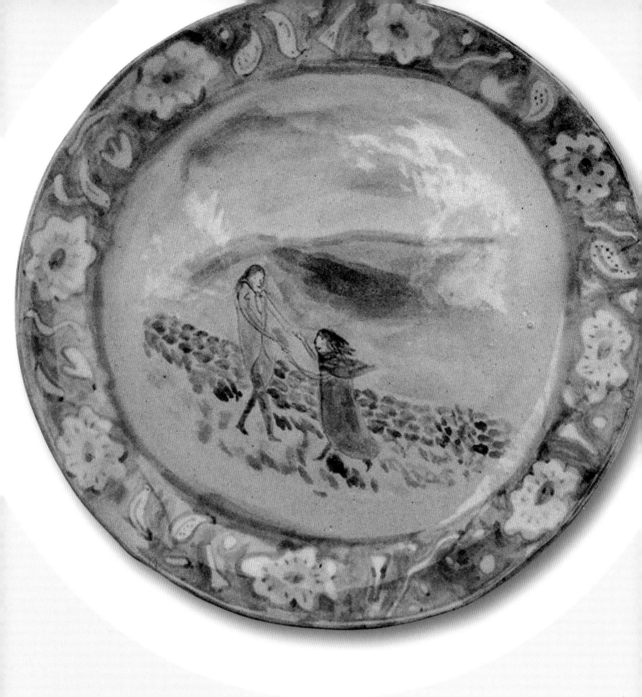

Wuthering Heights Plate 1, 2014
Ceramic

Lion in the Tree, 2015
White stoneware, underglaze

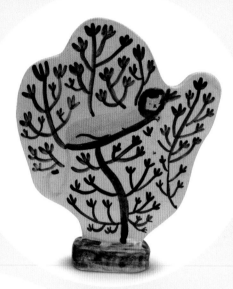

Hungry Leopard, 2015
White stoneware, underglaze

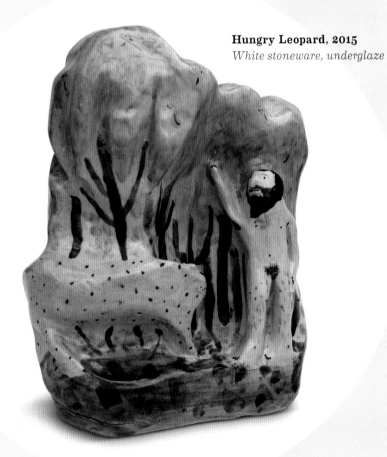

CHAPTER 2 : GRAPHIC

Lines, marks, and other surface patterns on clay

The ceramic objects on the following pages are adorned with all kinds of beautiful forms, from simple geometric shapes to text, a woman's figure, and nature-inspired motifs.

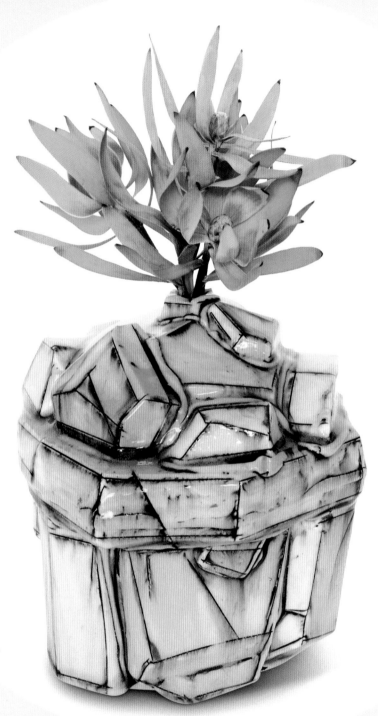

Weed Pot, 2015
Porcelain, Mason stains

BRETT FREUND

BORN

Pittsburgh, Pennsylvania, 1983

CURRENT LOCATION

Minneapolis, Minnesota
www.brettfreundportfolio.com

BIOGRAPHY

Originally from Pittsburgh, Brett Freund has studied and traveled in many different cities across the United States. In 2012 he received his Master of Fine Arts from Southern Illinois University Edwardsville and was awarded the Lormina Salter Fellowship from Baltimore Clayworks. Freund was selected as a 2012 Emerging Artist by *Ceramics Monthly*. He currently lives in Minneapolis and works out of a studio in his home, and has exhibited both nationally and internationally.

ARTIST STATEMENT

When working I think about my own definitions of preciousness and value. How does an object qualify itself as being unique? Is what I'm after rare like a diamond, does it take time to grow like a crystal, or is it a symbol that references a status or identity? I've been working with clay for almost ten years. Now that I have all that time and hard work behind me, I would never want to go back. I work with clay because it best connects my ideas with others in a way nothing else ever has. Ceramic objects are personal objects for both the maker and the admirer.

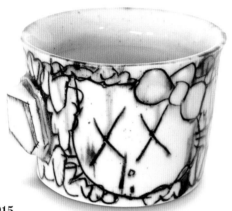

Sketch Cup 2, 2015
Porcelain, Mason stains

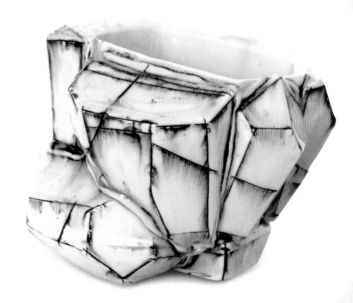

Gem Pot 1, 2015
Porcelain, Mason stains

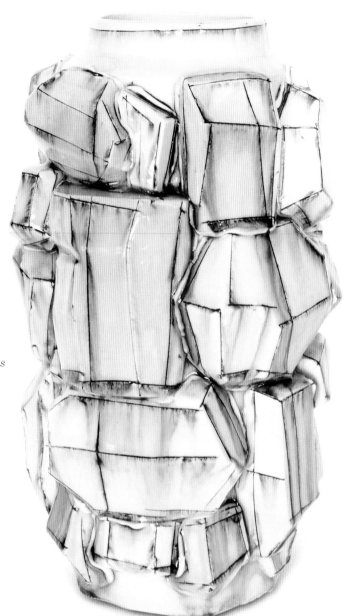

Gem Pot 3, 2015
Porcelain, Mason stains

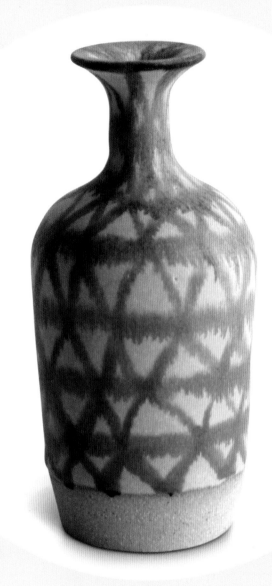

Vase 2, 2015
Stoneware

EMILIE HALPERN

BORN

Paris, France, 1976

CURRENT LOCATION

Los Angeles, California
www.emiliehalpernpottery.tumblr.com

BIOGRAPHY

Born in Paris, Emilie Halpern has since relocated to Los Angeles, where she received her Bachelor of Arts from the University of California, Los Angeles, in 1998, and her Master of Fine Arts from Art Center College of Design in Pasadena, California, in 2002. Her work has been exhibited at numerous galleries, including Blum & Poe (Los Angeles) and Leo Koenig (New York). Her work is inspired by Japanese Arita pottery.

ARTIST STATEMENT

I started making ceramics in 2009. Before that, I was known mostly for my photography, videos, and sculptures. I originally fell in love with art because I loved making it. There was so much pleasure in it for me. Somehow over the years I robbed myself of the pleasure of making and being in the studio. Being an artist was already hard enough, and I was deciding to make it harder. It was time for me to change. That's when I decided to work in ceramics. Having a conceptually based practice, ceramics was the perfect counterbalance. I needed to get my hands dirty again.

Vase 1, 2015
Stoneware

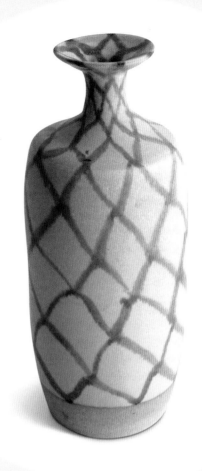

Cup, 2015
Stoneware

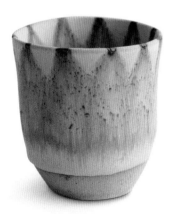

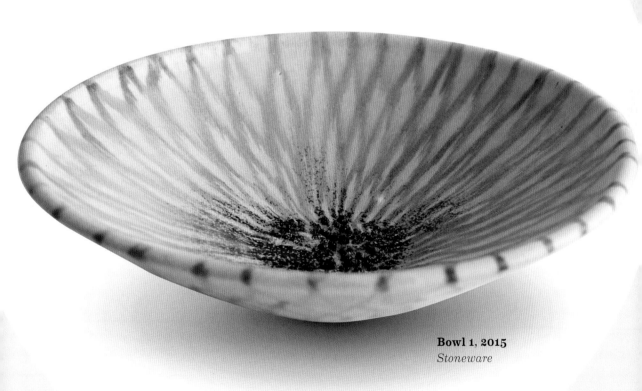

Bowl 1, 2015
Stoneware

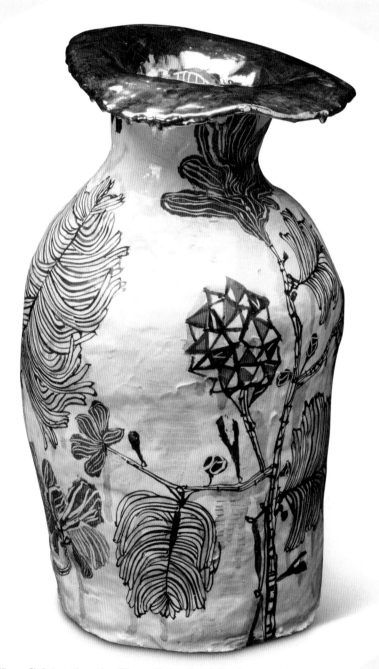

Large Vase Celebrating the Three Friends of Spring, 2014
Earthenware, colored porcelain slip, china paint, ceramic decals, and gold luster

RUAN HOFFMANN

BORN

South Africa, 1971

CURRENT LOCATION

Amsterdam, The Netherlands
www.ruanhoffmann.com

BIOGRAPHY

Ruan Hoffmann was born in South Africa and currently resides in Amsterdam. His oeuvre spans over two decades of work in a wide variety of media, but he is primarily known for his work in ceramics. Hoffmann's work is in numerous collections, including the South African National Gallery and South African National Association for the Visual Arts, both in Cape Town. He has had solo exhibitions at Galerie à Rebours (Paris) in 2014, The Gallery (London) in 2012, and Anthropologie Gallery (New York) in 2011.

ARTIST STATEMENT

Ceramics have an intrinsic place in society for their utility, and bring a tactile intimacy to my artwork. My work is primarily an expression of my personal awareness translated into narrative, text-based decoration.

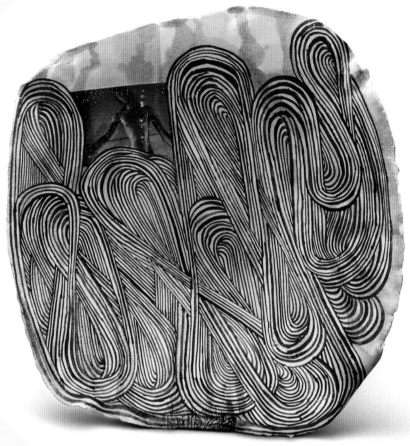

Night Swimming, 2014
Earthenware paperclay, ceramic decals

You & I Are Earth, 2014
*Earthenware, colored porcelain
slip, and platinum luster*

You & I Are Earth, 2014
*Earthenware, colored porcelain
slip, and platinum luster*

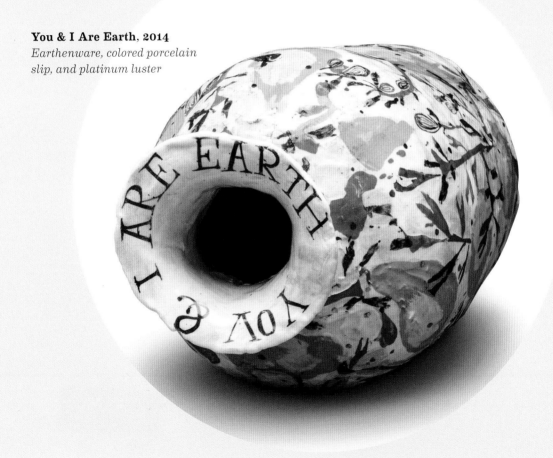

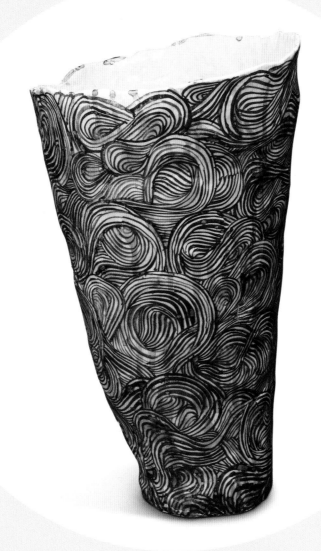

Mer Méditerranée, 2014
*Earthenware, colored porcelain
slip, and decal*

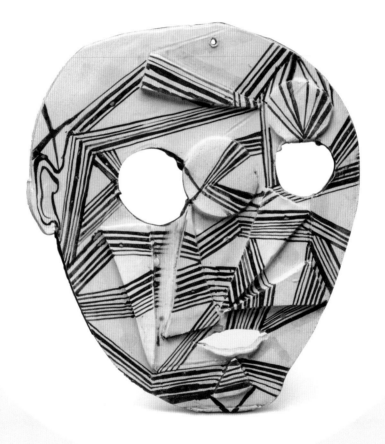

Large Pink Mask, 2014
*Earthenware paperclay, colored
porcelain slip*

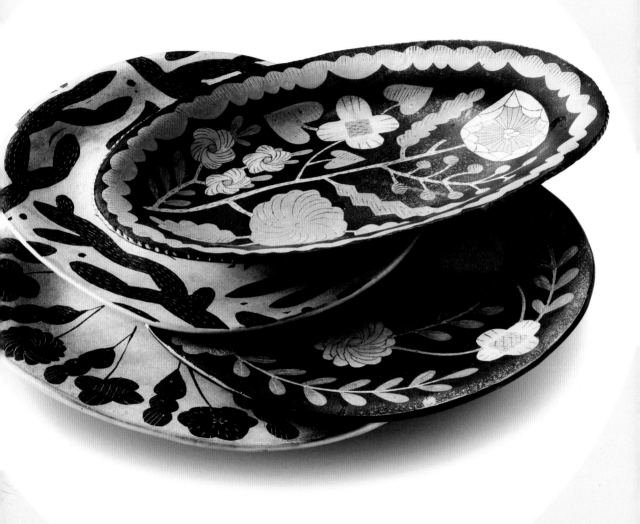

Untitled, 2015

Ceramic, natural glaze

MAKOTO KAGOSHIMA

BORN

Fukuoka, Japan, 1967

CURRENT LOCATION

Fukuoka, Japan
www.makotokagoshima.net

BIOGRAPHY

Makoto Kagoshima was born and is based in Fukuoka in the southern, tropical tip of Japan. He individually illustrates each dish, drawing inspiration from travels, his love for Roman sculpture and architecture, and the natural world. An avid gardener, Kagoshima often paints motifs of pansies, roses, and dianthus flowers. His works are exhibited in select galleries and stores in Japan. In 2013 he had his first show in the United States, at Chariots on Fire in Venice, California.

ARTIST STATEMENT

"Si je puis" *(if I can)* —*William Morris*

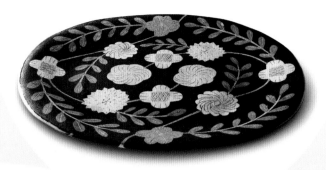

Untitled, 2015
Ceramic, natural glaze

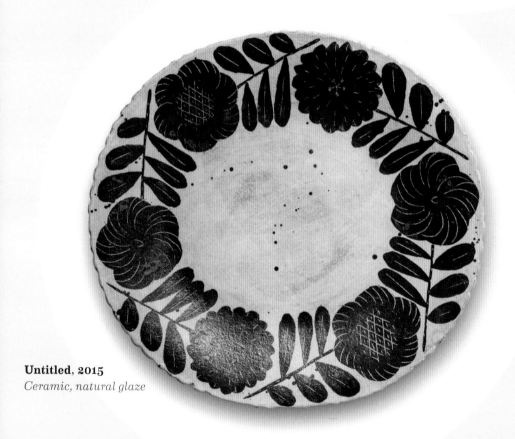

Untitled, 2015
Ceramic, natural glaze

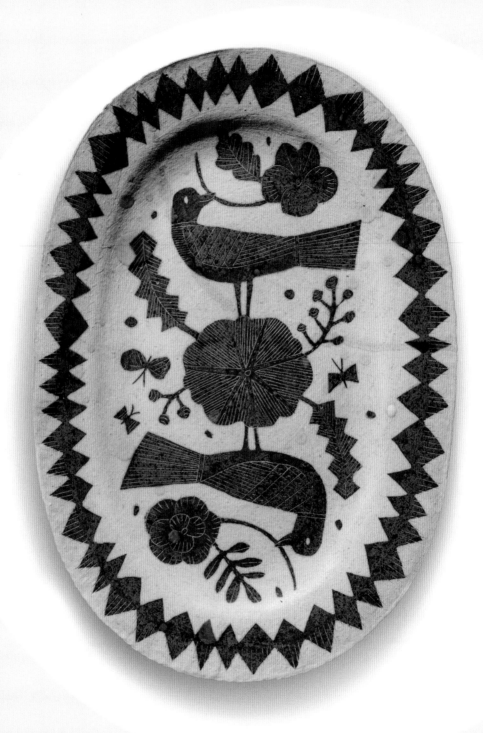

Untitled, 2015
Ceramic, natural glaze

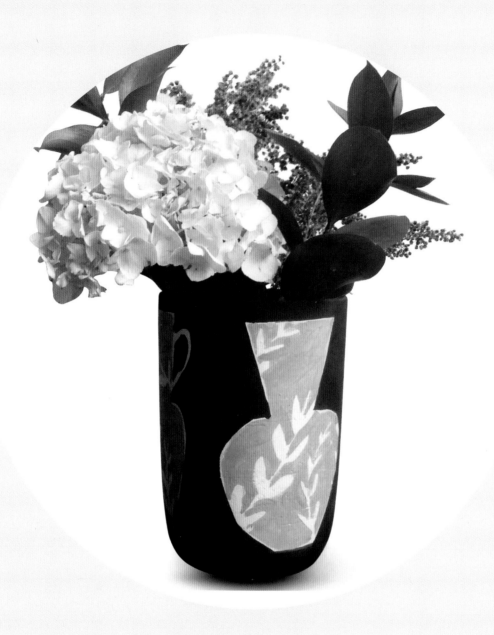

Blue Vase Vase, 2014
Stoneware, underglazed exterior, clear glazed interior

COURTNEY TATE

BORN

Chicago, Illinois, 1984

CURRENT LOCATION

Atlanta, Georgia
www.sandwichshop.us
www.sandwichshop.us/shop

BIOGRAPHY

Courtney Tate was born in Chicago, Illinois, in 1984, to a pair of illustrator parents. Tate studied at the Savannah College of Art and Design in Georgia, earning a Bachelor of Arts in Illustration in 2006. She presently lives and works from her home studio in Atlanta.

ARTIST STATEMENT

Making ceramics started as an exploration to be able to focus my creative energy in a different way during a time when I was struggling to make something out of a freelance illustration career while living in Brooklyn. I had tried my hand at still-life photography and found a real hobby in gathering objects that had interesting size, shape, and color relationships. I was heavily focused on shapes and what kind of purpose they have and stories they tell, and I wanted to bring some of my two-dimensional work to life. What appealed to me most about ceramics was being able to make something I could use that I also liked to look at. It took me a long time to figure out how to make the clay work for me instead of the opposite. Once I found my groove making shapes, I knew I could marry my formal training as an illustrator to the process of creating functional objects.

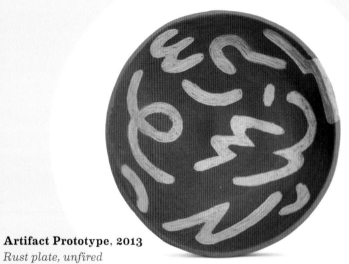

Artifact Prototype, 2013
Rust plate, unfired

Shapes Vase, 2014
Stoneware, underglazed exterior,
clear glazed interior

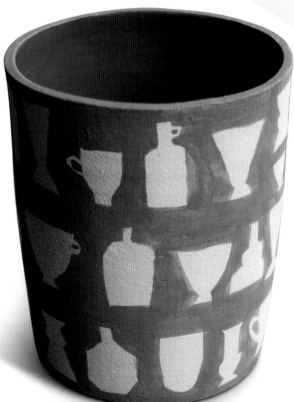

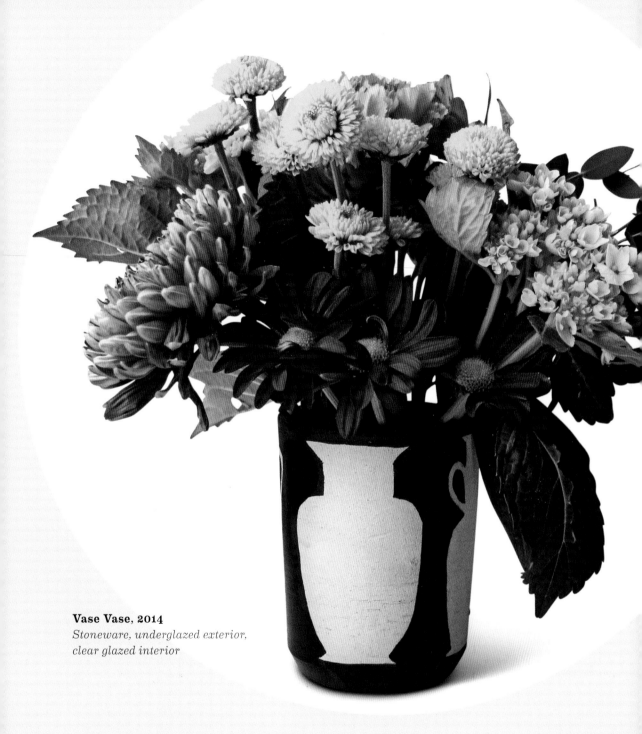

Vase Vase, 2014
Stoneware, underglazed exterior,
clear glazed interior

77

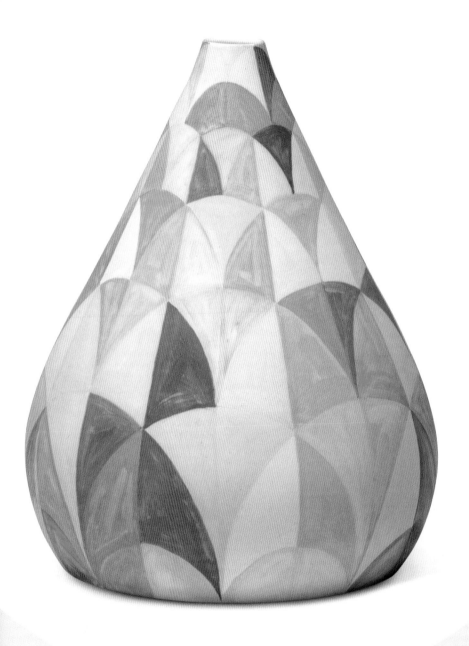

In Radiant Moments, 2014
Porcelain, ceramic stains

TANIA ROLLOND

BORN

Esperance, Australia, 1973

CURRENT LOCATION

Mittagong, Australia
www.taniarollond.com

BIOGRAPHY

Tania Rollond is an Australian artist who makes ceramics and drawings, often combining the two. She studied design at Curtin University, ceramics at the National Art School (NAS) in Sydney, and recently completed her Master of Fine Arts in Drawing at the University of New South Wales. Currently a lecturer in ceramics at NAS, Rollond has been teaching and exhibiting regularly since 2001.

ARTIST STATEMENT

The focus of my ceramic work is the dialogue between an object and the image on its surface (the real and the illusory). I draw from memory, building up images that link fragments of one place, object, or observation with thoughts or images from other times. They come together in a composition that responds directly to the ceramic form, through a process involving both conscious decision and unconscious play. Ceramics seems to be just the right balance of mind and body for me. Working with clay is direct, immediate, physical, while drawing and painting on the surface is more intellectual, formal, and contemplative. I love the challenge of working in both two and three dimensions, and remain hopelessly addicted to the transformation that happens in kilns.

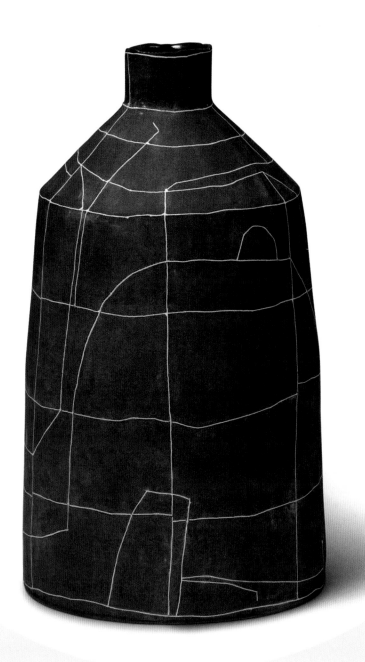

Along Those Lines, 2013
Stoneware, inlaid slip

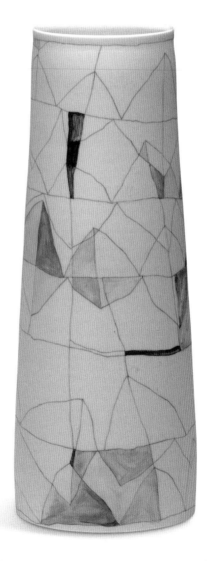

Fracturing, Vermillion, 2014
Porcelain, ceramic pencil, and stains

TANIA ROLLOND

Remnant Landscape, 2013
Porcelain, ceramic stains

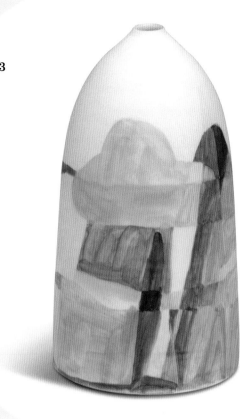

Untitled Cup, 2013
Porcelain, ceramic stains

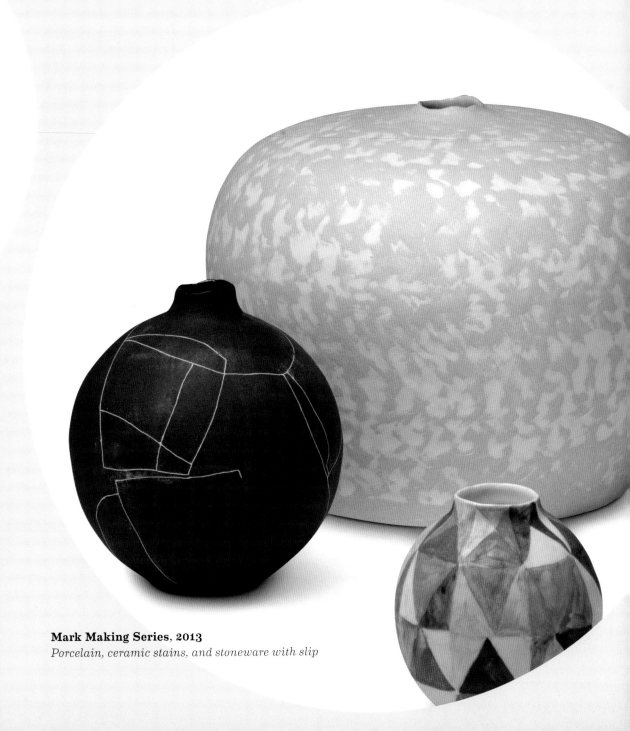

Mark Making Series, 2013
Porcelain, ceramic stains, and stoneware with slip

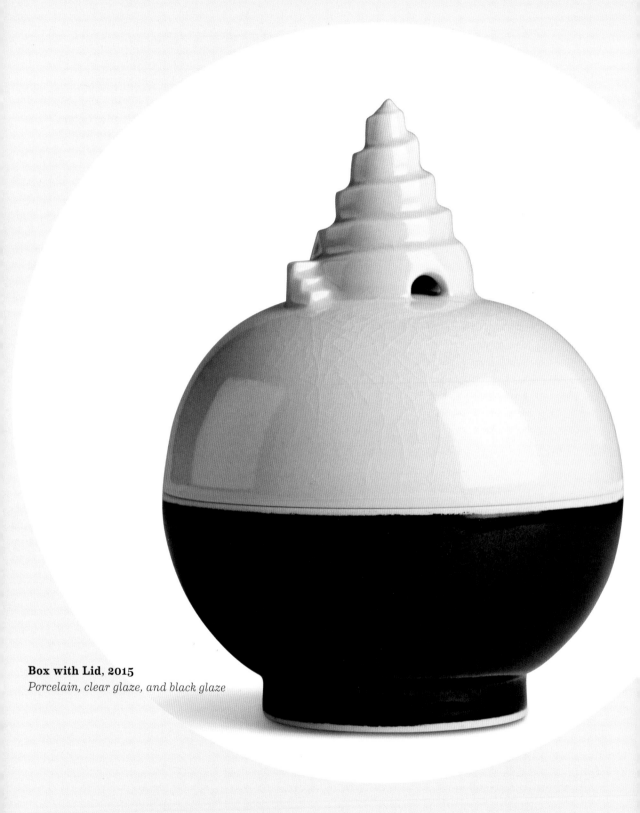

Box with Lid, 2015
Porcelain, clear glaze, and black glaze

RENAUD SAUVÉ

BORN

Montréal, Québec, Canada, 1967

CURRENT LOCATION

Irlande village, Québec, Canada
www.ateliersdescentans.com

BIOGRAPHY

Renaud Sauvé, whose studio is known as Ateliers des Cent Ans, is a ceramicist living and working in rural Québec. Sauvé studied philosophy, and previously worked as a set designer with Cirque du Soleil before taking up ceramics, studying at the Centre de Céramique Bonsecours in Montréal. He has exhibited his work a number of times at Mjölk, a gallery and shop in Toronto.

ARTIST STATEMENT

As a potter, I feel like I am in a constant dialogue with history and traditions in ceramics. I strive to make objects with my material of choice, porcelain. I live in a forest, and I try every day to find my own way to express and articulate my relationship with the world and nature.

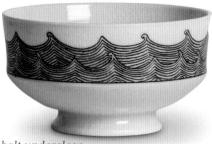

Bowl with Waves, 2014
Porcelain, clear glaze, and cobalt underglaze

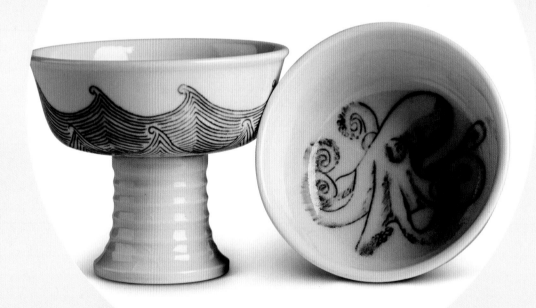

Step Cup with Waves and Octopus, 2015
Porcelain, clear glaze, and cobalt underglaze

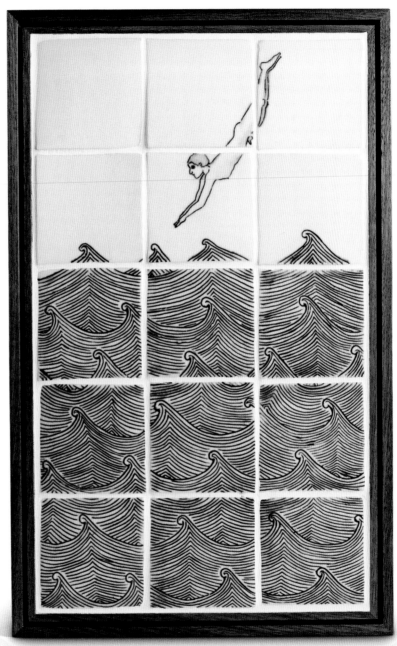

The Diver, 2015
Porcelain, clear glaze, cobalt underglaze, and dark walnut frame

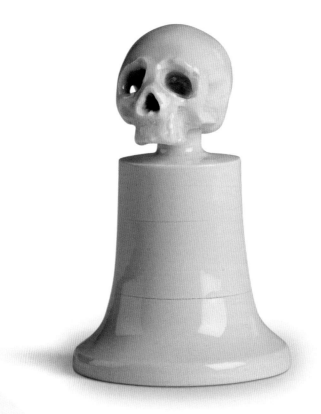

Skull Candle Snuffer, 2015
Porcelain, clear glaze

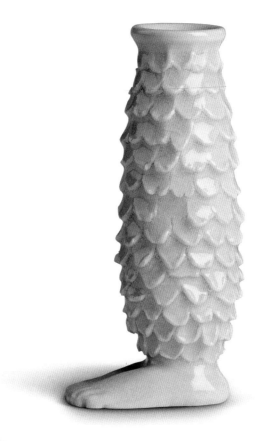

Soliflor, 2015
Porcelain, clear glaze

RENAUD SAUVÉ

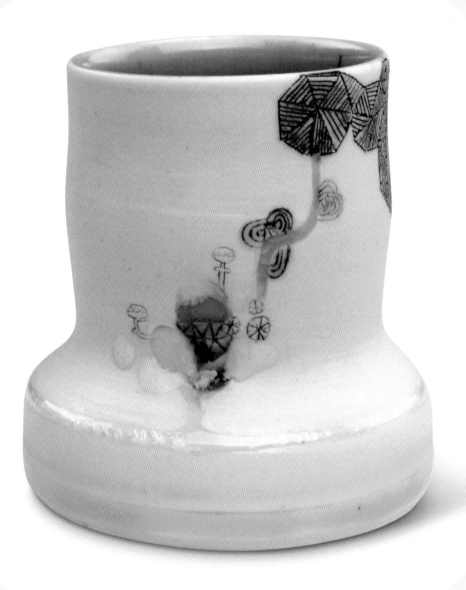

Yunomi 5, 2014
Porcelain

MICHELLE SUMMERS

BORN

Portland, Oregon, 1981

CURRENT LOCATION

Helena, Montana
www.michellemsummers.com
www.etsy.com/shop/whiteradish

BIOGRAPHY

Michelle Summers grew up just outside of Portland with a posse of cats, a dog, a rotation of lizards and fish, a band of horses, and her oddball family. She spent many childhood afternoons digging holes, making forts, and living in the alternate reality of her imagination. As an adult not much has changed. Her art is influenced by Chinese landscape painting and Japanese folk arts. In 2005 she received her Bachelor of Fine Arts from Alfred University in upstate New York, and in 2014 she received a Master of Fine Arts from the University of Minnesota. She is currently a wandering artist.

ARTIST STATEMENT

I create pottery as a way to tell my story and illuminate the landscapes of my imagination. My initial attraction to ceramics was the possibility of making my own pottery, but then before I knew it I was dedicated. Looking back, I think the material romanced me; it's very magical and mysterious when you first start working with it.

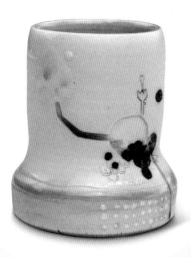

Yunomi 3, 2015
Porcelain

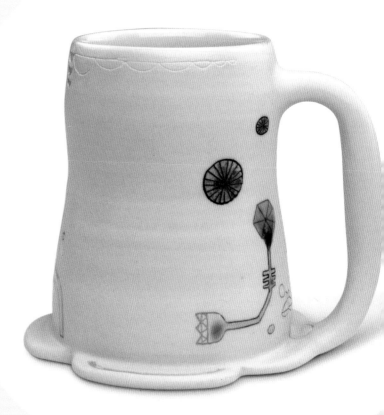

Melt Cup, 2014
Porcelain

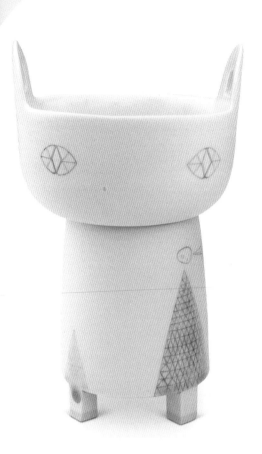
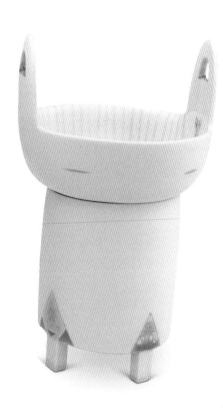

Walking Baskets, 2014
Porcelain

CHAPTER 3 : CURIOUS

The curious and magical conceived in clay

The unusual ceramics in this chapter go way beyond the expected with their humor, beauty and oddness.

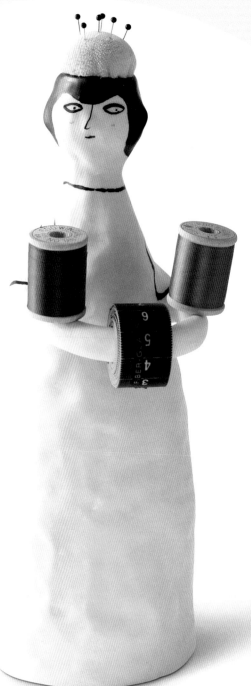

Sewing Lady, 2015
Paper porcelain, clear glaze, and paint

ELEONOR BOSTRÖM

BORN

Stockholm, Sweden, 1985

CURRENT LOCATION

San Francisco, California
www.eleonorbostrom.se
www.eleonorbostrom.tictail.com

BIOGRAPHY

Eleonor Boström is a Swedish ceramic artist and illustrator. She graduated in 2010 from Konstfack University College of Arts, Crafts, and Design with a Bachelor of Fine Arts in Ceramics and Glass. After graduating, she lived and worked in Berlin, and now works on her ceramics full-time in San Francisco.

ARTIST STATEMENT

I make quirky ceramics that are both functional and sculptural. I want my stuff to make you smile and clearly see that it's handmade, giving every piece its own character. I like how ceramics is very versatile. There are endless techniques to learn so you can constantly evolve and be better at your craft. It's not boring, but it can sometimes be a challenging material with its own will. I think that's something I like, that I don't always know the outcome—and that keeps me intrigued.

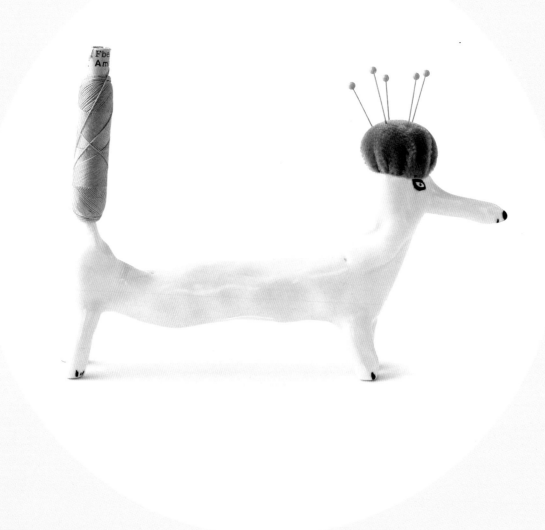

Pincushion Dog, 2015
Paper porcelain, clear glaze, and paint

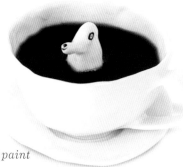

Dog in a Cup 1, 2015
Paper porcelain, clear glaze, and paint

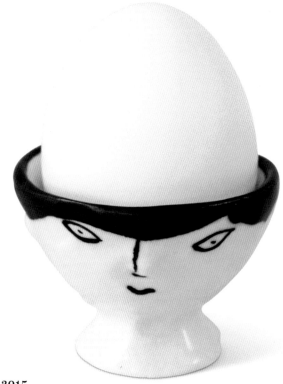

Egg Cup Guy, 2015
Paper porcelain, clear glaze, and paint

ELEONOR BOSTRÖM

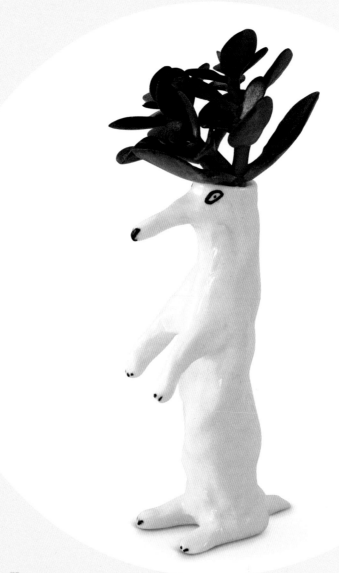

Flower Bud Dog Vase, 2015
Paper porcelain, clear glaze, and paint

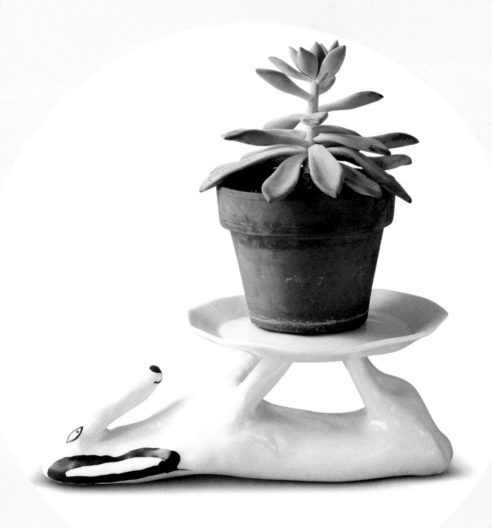

Pedestal Dog Stand, 2015
Paper porcelain, clear glaze, and paint

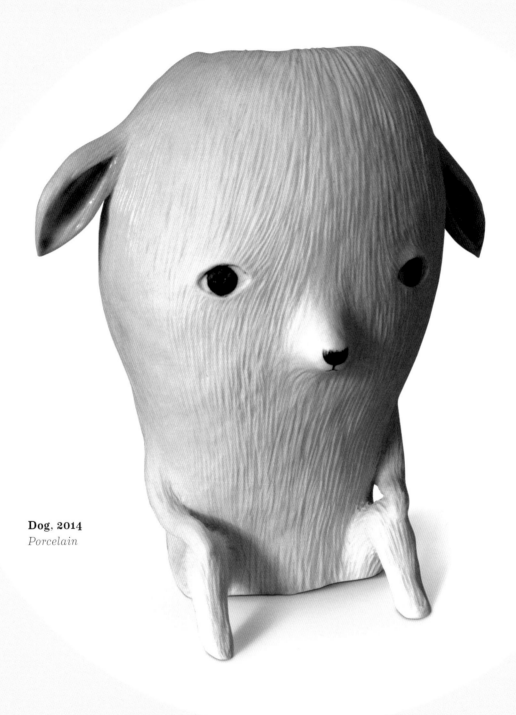

Dog, 2014
Porcelain

NATHALIE CHOUX

BORN

Nancy, France, 1967

CURRENT LOCATION

Montreuil, France
www.nathaliechoux.com

BIOGRAPHY

Nathalie Choux is a ceramicist based in France, known for her whimsical characters with delicate, supernatural features. She studied puppet making in Prague and illustration at Les Arts Décoratifs in Paris. Ten years ago Choux began taking night classes in ceramics. Today she has her own studio and divides her time between drawing and ceramics. She often collaborates with the ceramicist known as Lili Scratchy.

ARTIST STATEMENT

I like to think that my work shows a tender and nostalgic universe, but there is often a deeper meaning below the surface. Illustration and stories are strong influences in my work. The heroine in my artwork is half woman, half child, surrounded by half-human, half-animal characters. The characters are lost in a primitive, natural world that is both protective and threatening.

Bust with Flowers, 2013
Earthenware

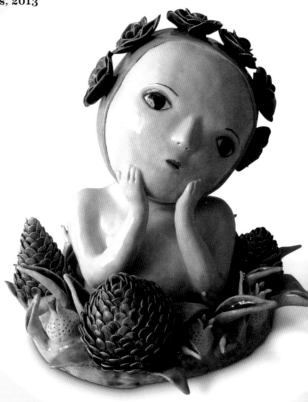

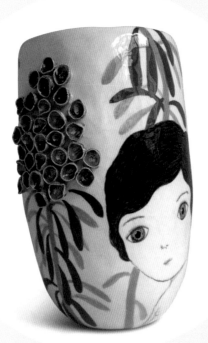

Euphorbia, 2014
Earthenware

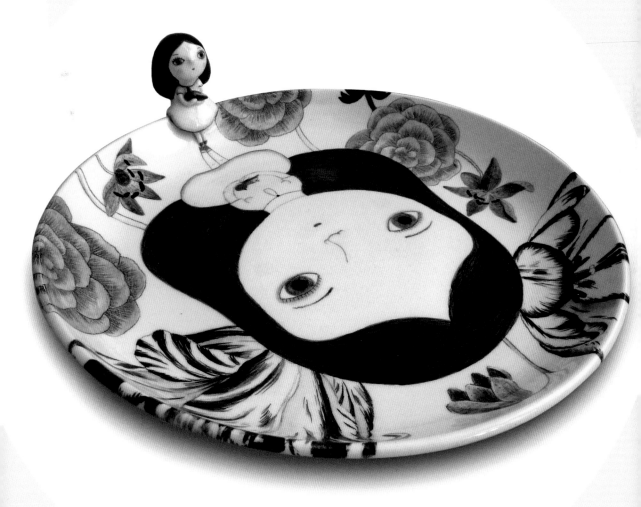

Among the Flowers, 2010
Earthenware

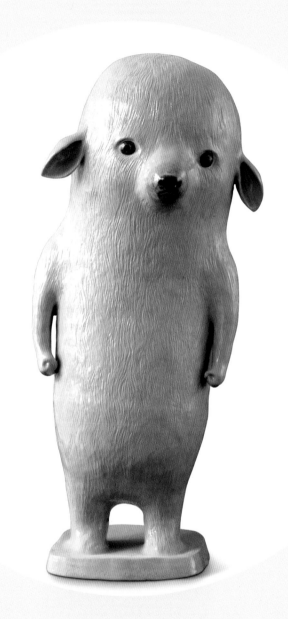

Angry Man, 2014
Colored earthenware

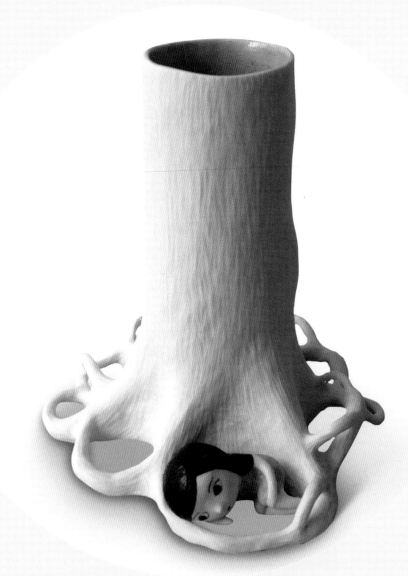

Trunk, 2013
Porcelain

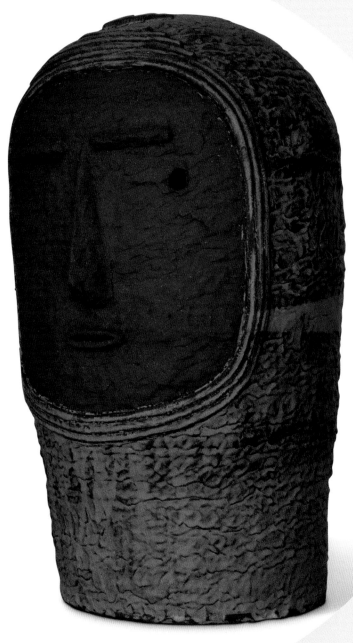

Untitled (heads), 2013
Stoneware

LAURENT DUFOUR

BORN

Caen, France, 1977

CURRENT LOCATION

Saint-Denis-de-Jouhet, France
www.dufourlaurent.com

BIOGRAPHY

Laurent Dufour is a self-taught artist who has been working in ceramics for the last ten years. In 2013 he was a winner of the Salon Contrastes, Roubaix. His work has been published in *La Revue de la Céramique et du Verre* in 2011 and 2013, and he has exhibited extensively across Europe.

ARTIST STATEMENT

My sculpture refers to the notion of the individual. Like a body covered in tattoos, the lines weave and connect with one another. The process of making ceramics is such that unexpected results occur. Some details become fixed in the clay and others disappear. These are my stories of the earth, which tell of our every day; from our fragilities to our stubborn truths, the unconscious consciousness mingles our childhood follies with other realities, of the symbolism of dreams and of the mythological.

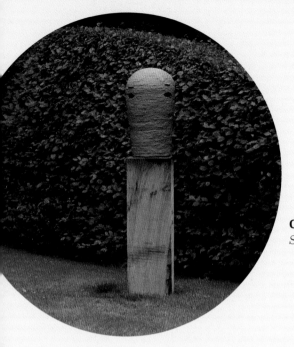

Gray, 2013
Stoneware

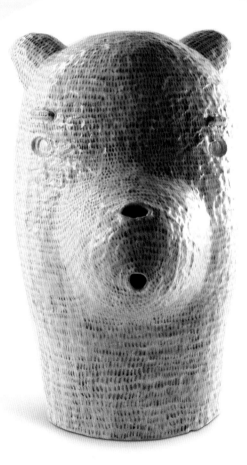

Bear, 2014
Stoneware

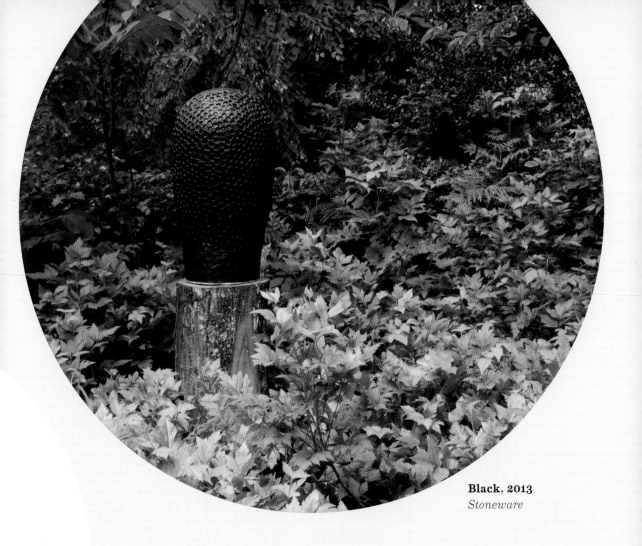

Black, 2013
Stoneware

111
LAURENT DUFOUR

The Animal Inside—My Self, 2011
Ceramic, colored pencil, graphite, and varnish

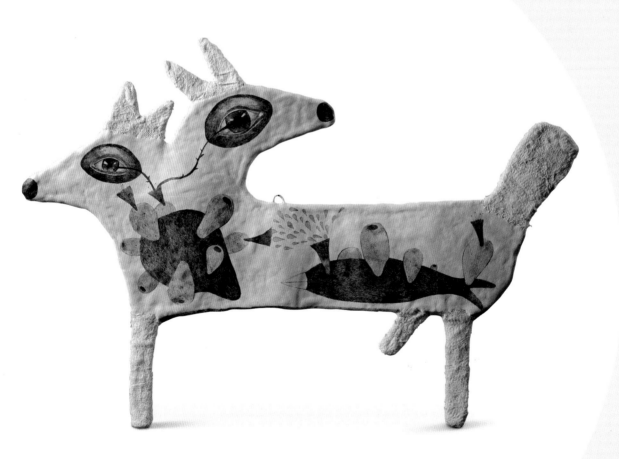

ILDIKO MURESAN & FLAVIA MARELE

BORN

Ocna Mureș, Romania (Muresan); Beiuș, Romania (Marele); both 1980

CURRENT LOCATION

Cluj-Napoca, Romania
www.harem6art.blogspot.ro
www.etsy.com/shop/doublefoxstudio

BIOGRAPHY

Ildiko Muresan and Flavia Marele first started working together in 2006 under the name Harem6. In the beginning of their collaboration, the duo made mixed-media art that combined digital photography and drawing. In 2009 they started making their one-of-a-kind sculpture after developing their own ceramic material, giving them the freedom to experience all kinds of shapes. Their sculpture also incorporates graphite, colored pencils, and acrylic paint.

ARTIST STATEMENT

Our creations are partly autobiographical and reflect our view of the world in a surreal manner. They are a call to be loving and caring toward all forms of life that surround us. All these works reflect our personalities: they are fragments of our souls; they are past experiences which come to the surface transformed into the surreal. We imagine our creations on a beautifully decorated stage where anything is possible.

A Love So Deep, 2013
*Ceramic, colored pencil,
graphite, and varnish*

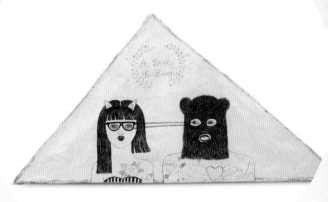

Katia, 2011
Ceramic, colored pencil, graphite, and varnish

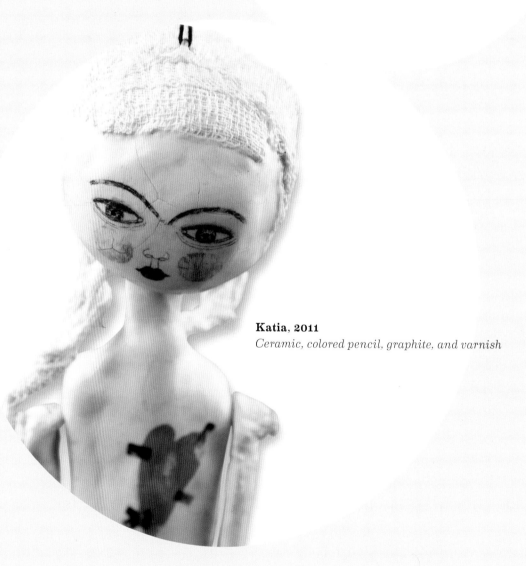

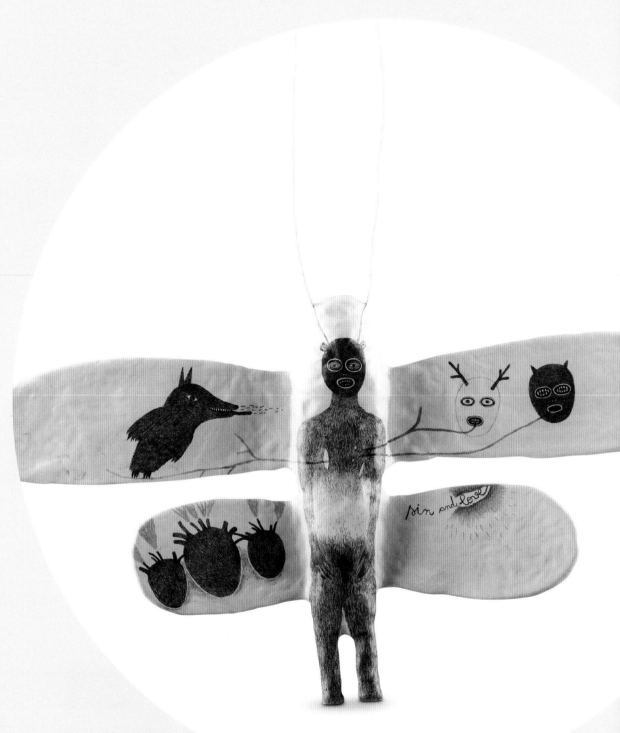

The Animal Inside—Sin and Love, 2013

Ceramic, colored pencil, graphite, and varnish

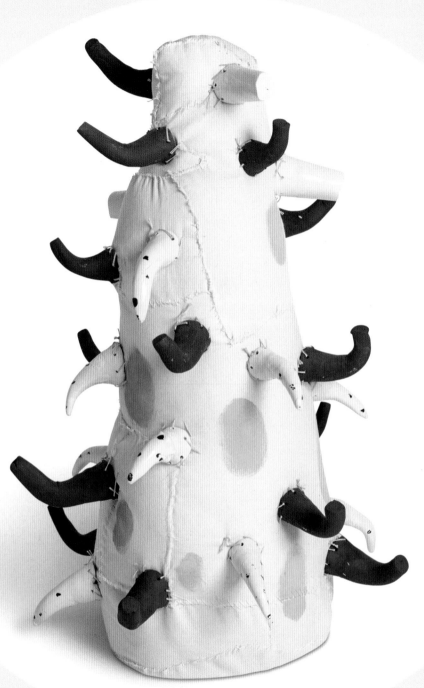

XXXX, 2014
Clay, enamel, and textiles

LAURA LASHERAS

BORN

Calahorra, Spain, 1979

CURRENT LOCATION

Barcelona, Spain
www.lusesita.net/en
www.galeriamiquelalzueta.net

BIOGRAPHY

Laura Lasheras, or "Lusesita" as she is known, hails from Calahorra, La Rioja, in northern Spain. She earned a Bachelor of Arts degree from the School of Arts and Crafts in Logroño and specialized in ceramics at the School of Arts and Crafts in Zaragoza. In 2004 Lasheras relocated to Barcelona, where she has since settled, to study enamel and contemporary jewelry. She holds workshops in Barcelona called "El Taller de Lusesita."

ARTIST STATEMENT

When I started my artistic training in high school I had the luck to discover ceramics; at that moment I felt the material's plasticity and its ability to transform and make magic.

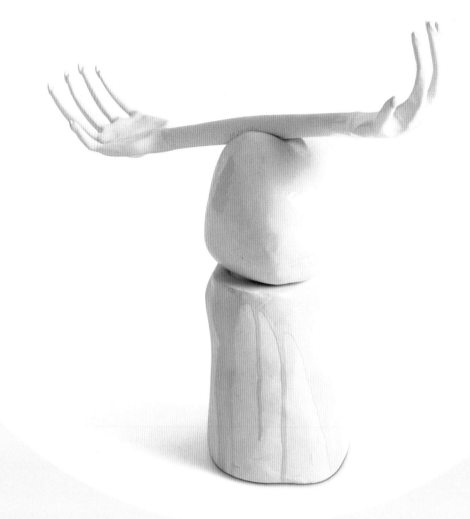

Balance, 2014
White clay, enamel

Frankfurt, 2014
White clay, enamel

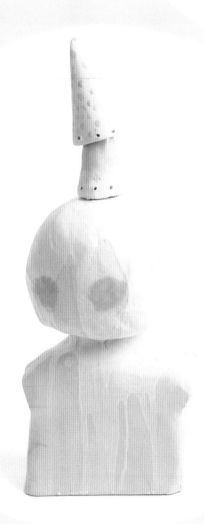

Bust, 2014
White clay, enamel

119

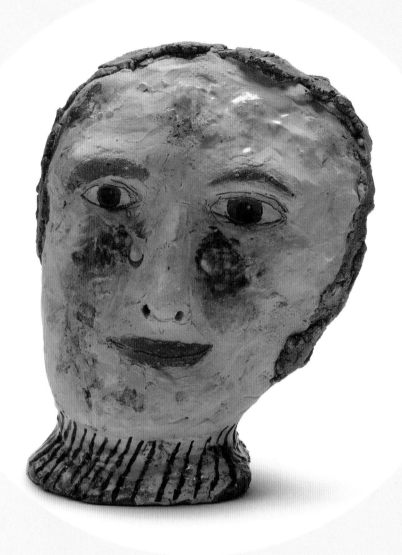

Left Leaning, 2013

White and red clay, slip, underglaze, and glaze

CLAIRE LODER

BORN

Cambridge, England, 1971

CURRENT LOCATION

Bath, England
www.claireloder.co.uk
www.claireloder.bigcartel.com

BIOGRAPHY

Claire Loder received a Bachelor of Arts from Bath Spa University and a Master of Arts in Ceramics from Cardiff Metropolitan University in Wales. She was a recipient of the Arts Council Grants for the Arts in 2009 and published a book, *The New Ceramics: Sculpting and Handbuilding,* in 2013. She is currently a lecturer in ceramics at Bath Spa University.

ARTIST STATEMENT

My ceramic heads are full of ideas, a union of twenty-first-century anxieties, wordplay, the influence of outsider art, and the communication of the interior world. These sculptures are a combination of intuitive construction, amorphous tactility, and off-kilter form. Clay is an extraordinary material, full of possibilities. It has a skin-like quality, it gathers marks, indentations—it cooperates in the making.

Painted Lady, 2013
White and red clay, slip,
underglaze, and glaze

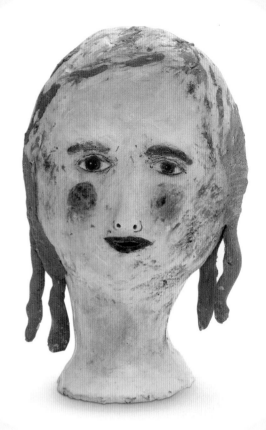

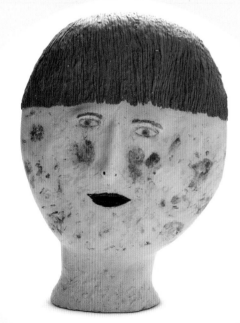

My Boy Lollipop, 2014
Grogged white clay, terra-cotta,
slip, glaze, and transfer

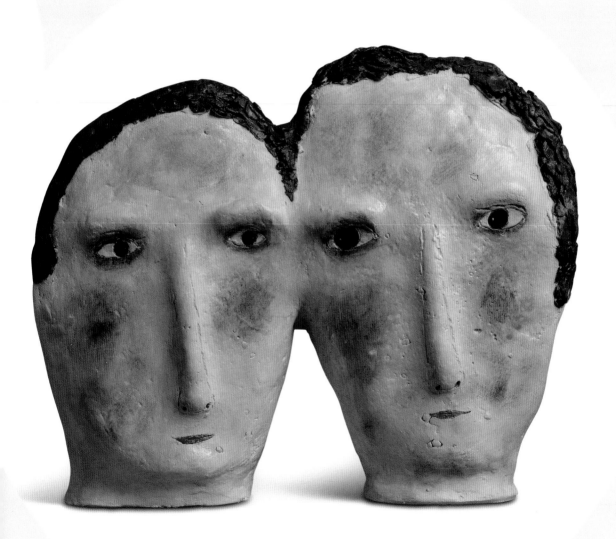

Together Alone, 2011
Grogged white clay, slip, underglaze, glaze, and oxide

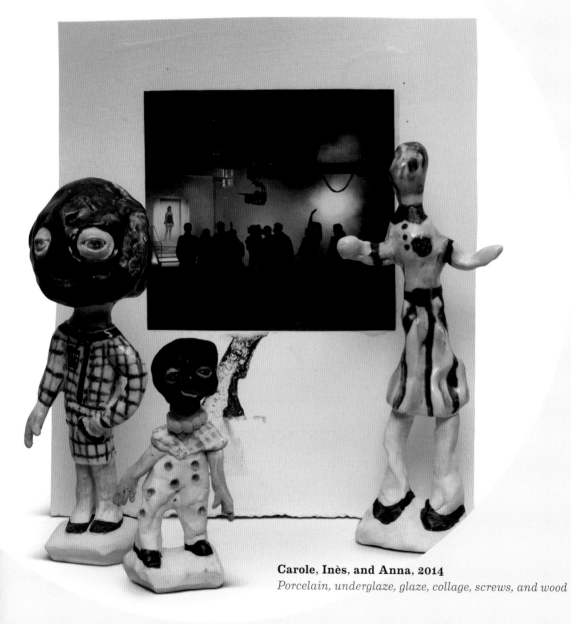

Carole, Inès, and Anna, 2014
Porcelain, underglaze, glaze, collage, screws, and wood

MARGARET MEEHAN

BORN

Philadelphia, Pennsylvania, 1970

CURRENT LOCATION

Dallas, Texas
www.margaretmeehan.net

BIOGRAPHY

Margaret Meehan lives and works on the fringe, sometimes in Austin, Texas, and sometimes in Dallas. She completed artist-in-residencies at Artpace International in San Antonio, Texas in 2014 and at The Lighthouse Works on Fishers Island, New York, in 2013. In addition to her sculpture, Meehan has also launched a line of "monsterware" called Sister Hyde Ceramics.

ARTIST STATEMENT

Combining fact and fiction that reference 1950s horror movie kitsch, I investigate otherness and human nature by linking a fashion icon's legacy (Coco Chanel) to a fictional creature from Mary Shelley's Frankenstein. *With playful humor and macabre tease, the victim becomes the monster and the monster becomes the fashion victim. I actually work in every material, depending on the project, but my love of clay and its potential for surface, form, and content is why I continue to return to it again and again.*

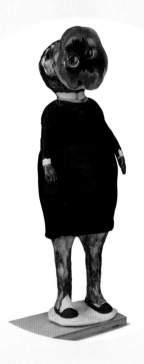

Little Black Dress, 2014
Porcelain, underglaze, glaze, ink, collage, Velcro, and wood

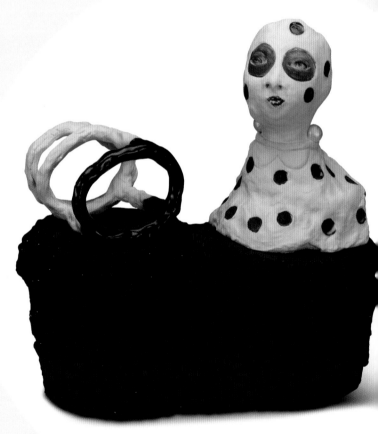

Marilyn, 2014
*Porcelain, underglaze, glaze,
collage, and wood*

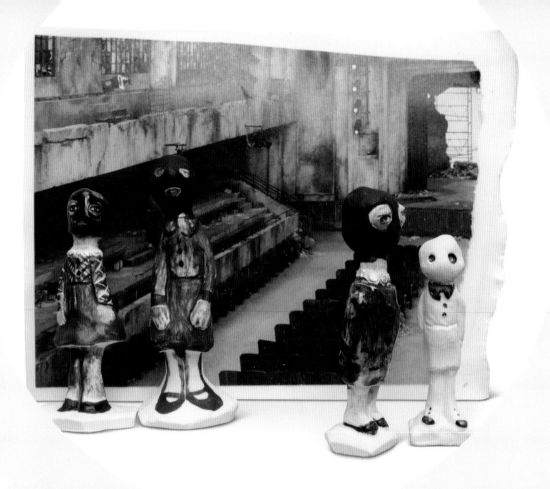

Golems on a Catwalk, 2014
Porcelain, underglaze, glaze, ink, collage, screws, and wood

127
MARGARET MEEHAN

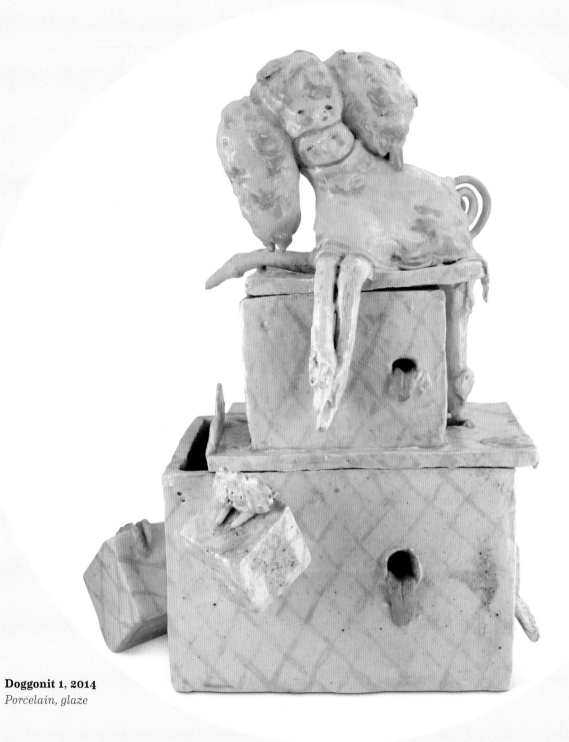

Doggonit 1, 2014
Porcelain, glaze

EUN-HA PAEK

BORN

Seoul, Korea, 1974

CURRENT LOCATION

Brooklyn, New York
www.eun-ha.com

BIOGRAPHY

As a child, Eun-Ha Paek loved reading stories, and dreamed of writing them too. But language shifted around her—she lived in four different countries before she turned ten, and perhaps because of that, visual art rather than literature became her medium. With a Bachelor of Fine Arts from the Rhode Island School of Design, she worked as an animator for twenty years (with screenings of her films in the Guggenheim Museum, the Sundance Film Festival, and other venues internationally), but lately has become focused on ceramics.

ARTIST STATEMENT

A boulder at the edge of a hill stores potential energy. In the same way, a banana peel on the floor stores potential "ha-has." It's the setup to a joke, and without anybody having to slip and fall, just seeing that setup might cause a smirk. My work uses this potential to construct narratives on the precipice of the familiar and the strange—to explore our inner workings of hope and grief, with humor. My art used to only exist behind the screen, but with ceramics, it's been exciting to translate ideas into tangible objects that live in my environment. As far as material goes, ceramic is inexpensive and easy to work with. It has a history, which gives the object inherent meaning by association. It's fun to try to play off that and make things that seem familiar and strange at the same time.

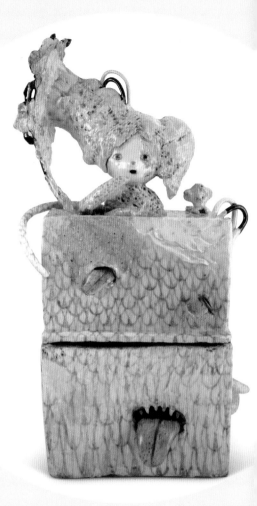

Doggonit 2, 2014
Porcelain, glaze

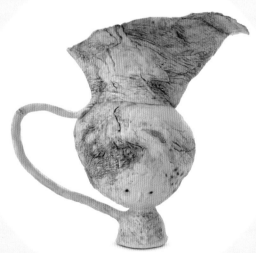

Man Without a Vase, 2014
Porcelain, paperclay, and glaze

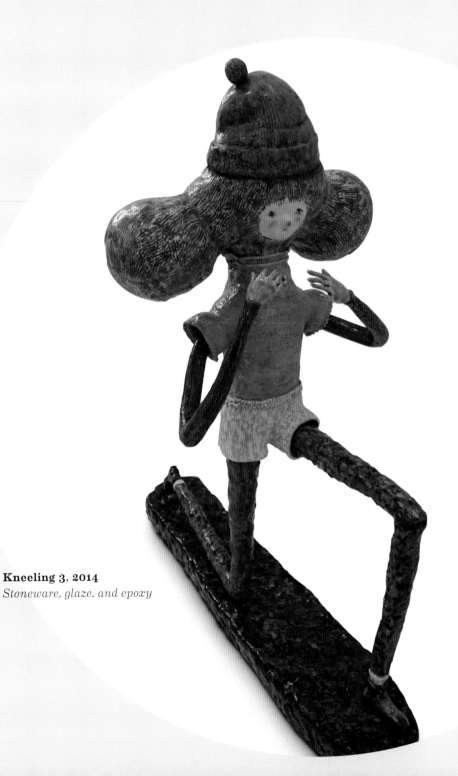

Kneeling 3, 2014
Stoneware, glaze, and epoxy

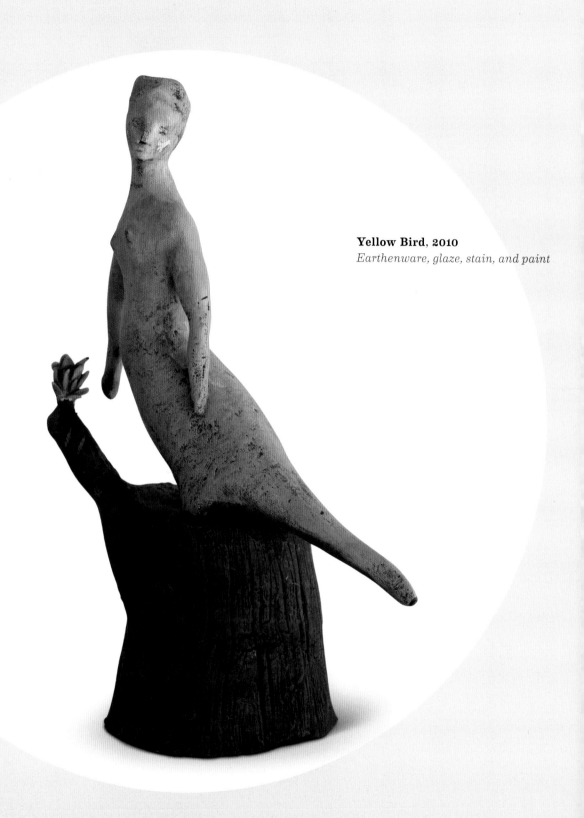

Yellow Bird, 2010
Earthenware, glaze, stain, and paint

BONNIE MARIE SMITH

BORN

Lockport, New York, 1972

CURRENT LOCATION

Kingston, New York
www.bonniemariesmith.com

BIOGRAPHY

Bonnie Marie Smith currently lives and works in the Hudson Valley of New York state. She grew up on a farm in western New York and later studied art and ceramics at the New York State College of Ceramics at Alfred University. She enjoys all kinds of art-making, but her focus is primarily in figurative ceramics.

ARTIST STATEMENT

In my work I am exploring materials, and I am exploring myself. In life and in art I am drawn to small and intimate things, to the strange, the wounded, the outcast, the mystical and mysterious, the hidden parts and pieces. I started working with ceramics twenty years ago, and it was love at first touch. Though I was trained first in drawing and painting, clay has a satisfaction for me like no other material. It is clay that can most sensitively record the subtlest of gestures and expressions in my figures. I love the surprise of ceramics, the experiments with glazes and materials, the wonder as I open the kiln.

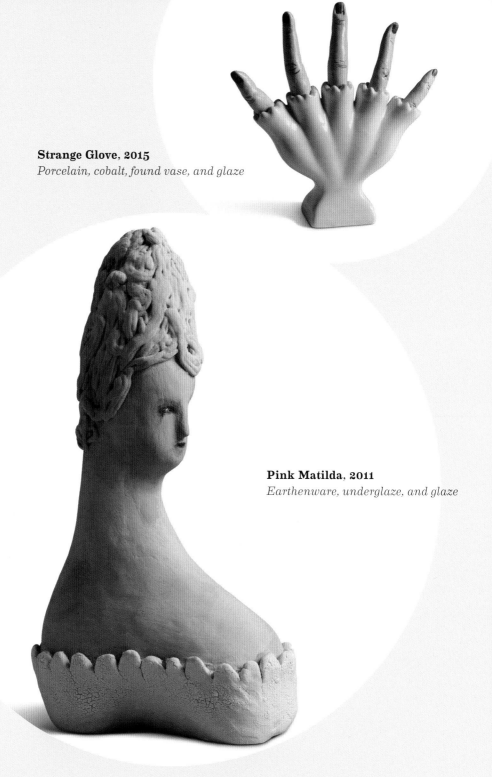

Strange Glove, 2015
Porcelain, cobalt, found vase, and glaze

Pink Matilda, 2011
Earthenware, underglaze, and glaze

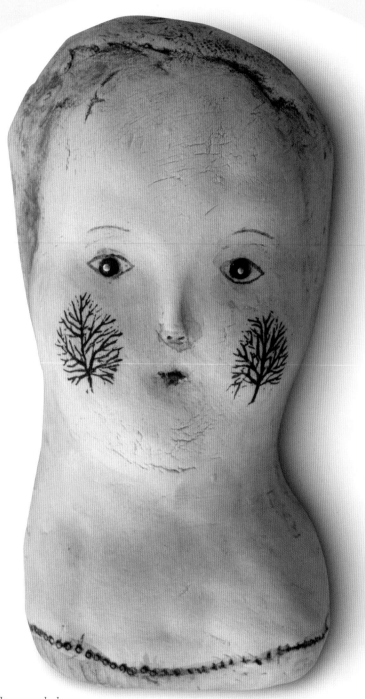

Tree Cheeks, 2010
Earthenware, underglaze, and glaze

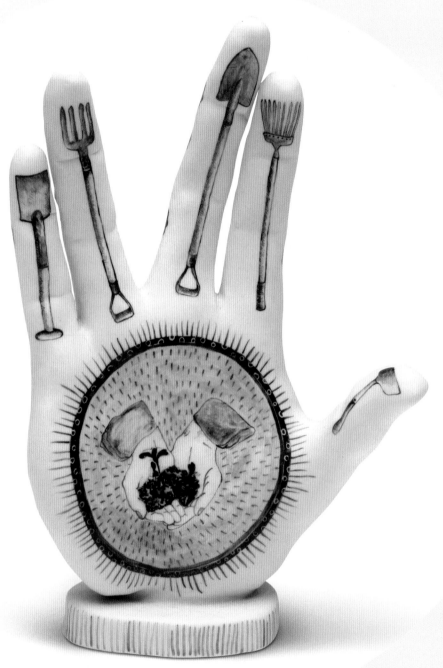

Kookaburra, 2008

Cool ice porcelain, cobalt paint, and ceramic pigment

VIPOO SRIVILASA

BORN

Bangkok, Thailand, 1969

CURRENT LOCATION

Melbourne, Australia
www.vipoo.com

BIOGRAPHY

Thai-born, Melbourne-based artist, curator, and arts activist Vipoo Srivilasa works predominantly in ceramics, but also produces animation, works on paper, and mixed-media sculptures. Srivilasa moved from Thailand to Australia in 1997 to complete a Master of Fine Art and Design in Ceramics at the University of Tasmania. Since then he has held twenty-three solo exhibitions in Australia, Thailand, and China, and participated in over one hundred curated exhibitions across seventeen countries. His work has been exhibited in major international institutes, including the Museum of Fine Arts, Boston; Saatchi Gallery (London); L'Alcora Ceramics Museum (Spain); Fine Arts Museum (Vietnam); and the National Art Gallery (Thailand).

ARTIST STATEMENT

As a Thai-born Australian, I am interested in culture shift and the migration experience, how the change of culture and places affects people. My work comes out of my experience living between two homes, Australia and Thailand.

I like clay because it is a versatile medium to create art. I also love the idea of turning a humble material into something fabulous and beautiful. I like working with my hands, and clay is the best medium to do so. The excitement of opening the kiln is a big attraction, and after many years of working with clay, I still get excited every time I open the kiln. I also like painting and drawing, but somehow I always end up painting on clay.

Car, 2008
*Cool ice porcelain, cobalt
paint, and ceramic pigment*

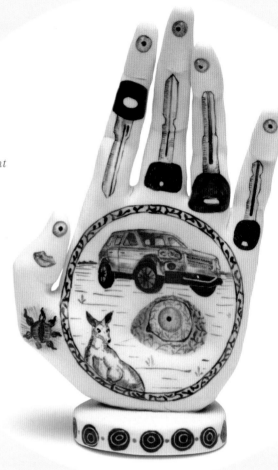

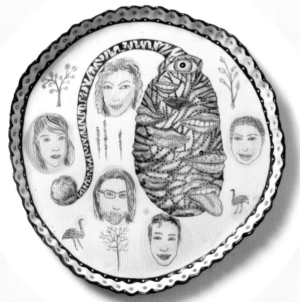

Joseph Banks, 2013
Porcelain, cobalt pigment

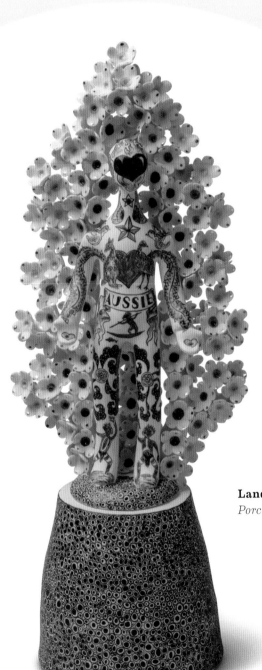

Land of Peace, 2015
Porcelain, cobalt pigment, and gold

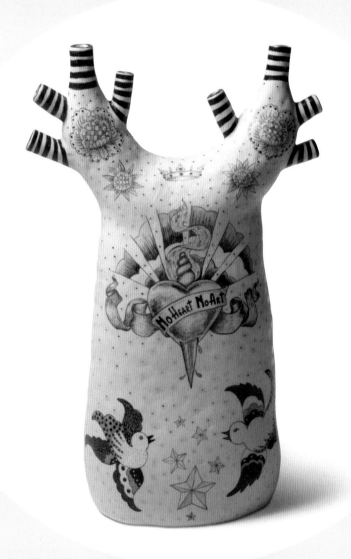

No Heart No Art, 2013
Porcelain, cobalt pigment

140

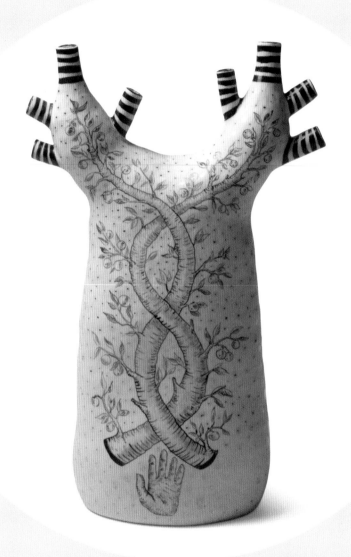

No Heart No Art (reverse side), 2013
Porcelain, cobalt pigment

CHAPTER 4 : ORGANIC

Ceramic objects as studies in form, material, and texture

The ceramics on the next pages are imbued with a strong connection to the earth communicated through rough finishes and cultivated imperfections.

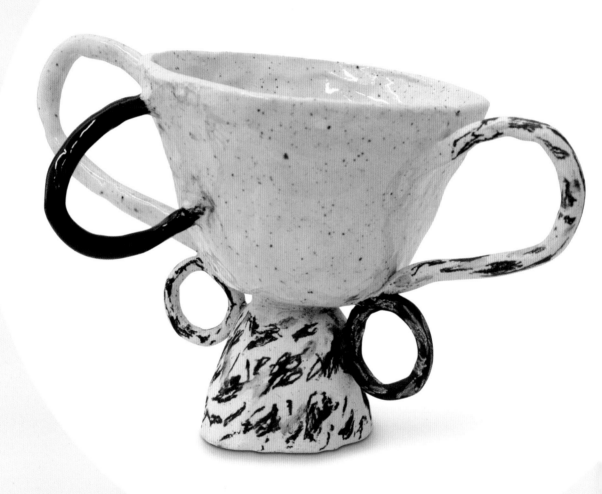

Untitled Trophy 1, 2015
Earthenware ceramic

SARAH BURWASH

BORN

Rossland, British Columbia, Canada, 1987

CURRENT LOCATION

Halifax, Nova Scotia, Canada
www.sarahburwash.com

BIOGRAPHY

Sarah Burwash grew up in Rossland and graduated from the University of British Columbia Okanagan in 2009 with an interdisciplinary Bachelor of Fine Arts. Her work is included in private and public collections internationally and has been shown in solo and group exhibitions in Canada, the United States, and Europe. She has participated in residencies across North America and abroad. Burwash is based in Halifax, working full-time as an artist and freelance illustrator.

ARTIST STATEMENT

I have been working in ceramics for four years. In contemporary art practices, including my own, there is space for a multitude of techniques and materials to intermingle and overlap. In my work, ceramic objects seem to spring to life out of the painting. For viewers, I think they act as playful and compelling access points into narratives in the work. There's a moment of suspension of disbelief about the strange mix of objects in the room and on paper. A particular focus in my work is challenging art-historical representations of the feminine and the female body. My human figures cast aside emphasis on physical perfection by achieving grace and beauty through displays of physical feats and emotional strength. I like to think the imperfection and playfulness in my ceramic design captures this motivation too.

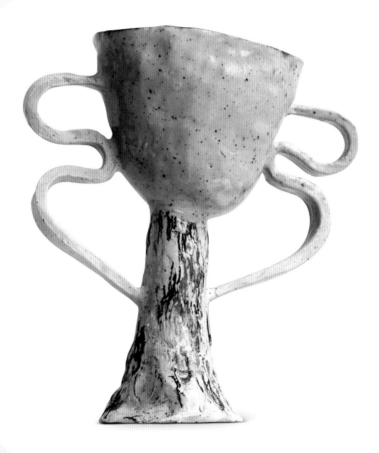

Untitled Trophy 2, 2015
Earthenware ceramic

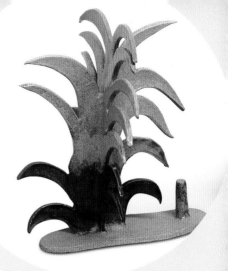

Untitled Ceramic Object 1, 2015
Earthenware ceramic

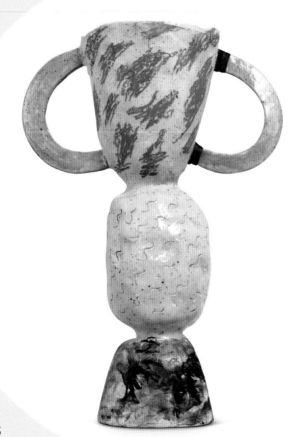

Untitled Trophy 3, 2015
Earthenware ceramic

147

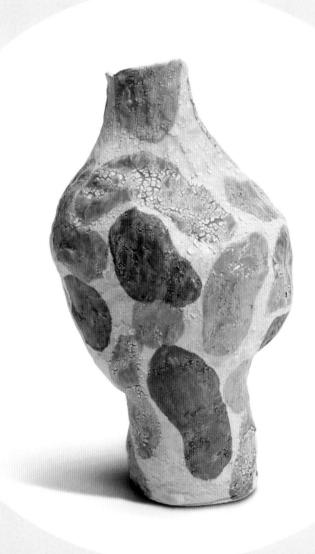

Clown Vase, 2014
Porcelain, glaze

JESSICA HANS

BORN

Camden, New Jersey, 1988

CURRENT LOCATION

Philadelphia, Pennsylvania
www.jessicahans.com
www.shop.jessicahans.com

BIOGRAPHY

Jessica Hans is a ceramicist, textile designer, and photographer living and working in Philadelphia. Hans studied fiber arts and ceramics at Maryland Institute College of Art and Moore College of Art and Design, first focusing on textiles and raw materials before discovering a passion for ceramics. Her work has been featured in online publications Thisispaper and Sight Unseen.

ARTIST STATEMENT

My work stems from an interest in the naturally occurring patterns and texture of rock and earth. My specialty is functional sculpture that retains its sense of self by leaving exposed the bare, raw material on the surface of the vessels. I will often add foraged rocks and minerals into the clay body and glaze for a more visceral experience, as if the objects themselves literally emerged from the earth. Flashes of brightly colored glaze appear against a dark, neutral body, reminiscent of molten lava or a slime mold developing on a rocky surface. I initially approached ceramics coming from a background in photography and textiles, including print design and weaving. While I flip-flopped from medium to medium in the past, I became hooked on the whole world of ceramic chemistry. And at the end of the day, the pure functionality of the material is very important to me.

Pink Dalmatian Vase, 2014
Porcelain, glaze

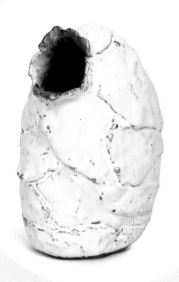

House for a Mouse, 2013
Stoneware, glaze

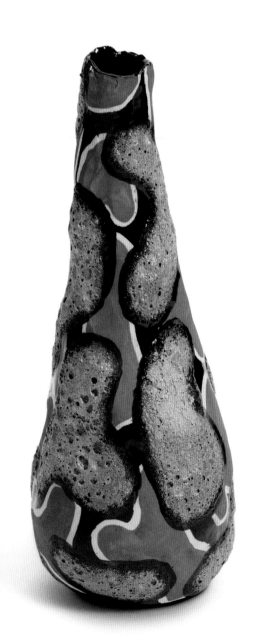

Algae Vase, 2011
Porcelain, glaze

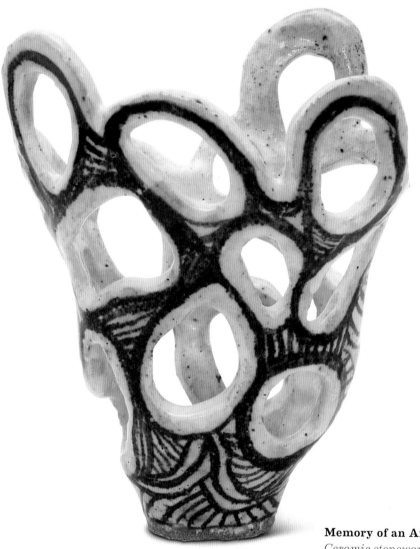

Memory of an Artifact III, 2013
Ceramic stoneware, glaze

KATY KRANTZ

BORN

Mount Holly, New Jersey, 1975

CURRENT LOCATION

Los Angeles, California
www.katykrantz.com

BIOGRAPHY

Katy Krantz earned her Master of Fine Arts from Hunter College and her Bachelor of Arts from the University of California, Santa Cruz, and was a Pollock-Krasner Fellow at the Woodstock-Byrdcliffe Art Colony in 2009. She has exhibited widely, showing her work at such venues as the Oakland Museum and the Richmond Art Center, both in California, as well as at the City Museum of Cuernavaca, Mexico. She has had solo shows at iKO iKO Space in Los Angeles, Totokaelo in Seattle, and Saffron in Brooklyn.

ARTIST STATEMENT

I believe handmade objects are imbued with the presence of the maker, and that moving an object out of the maker's hands and into another's is essentially a way to connect. Vessels in particular interest me for their ability to "hold" memory and experience. The ancient quality of the clay vessel appeals to me. When I am rolling, coiling, and pinching, I know that I am connected to every other human throughout history who has touched wet clay and then fired it. There is always some stress and anxiety upon seeing the newly fired work, because surprises, both good and bad, are a part of the deal. I don't see this loss of control as failure, but more as practice. My objects serve as visual documents of this fluid and dynamic process.

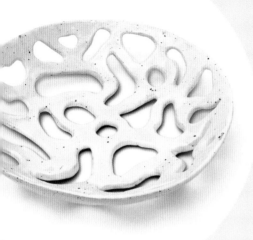

Fruit Bowl, 2014
Ceramic stoneware, glaze

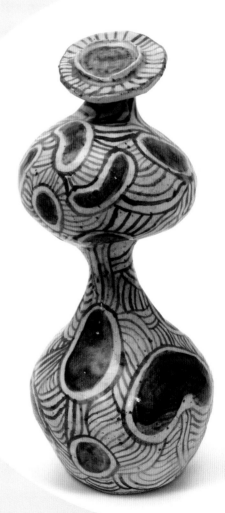

Ladylike, 2013
Ceramic stoneware, glaze

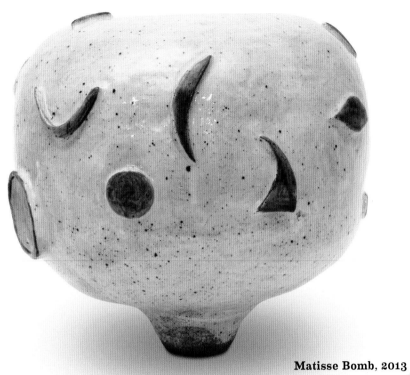

Matisse Bomb, 2013
Ceramic stoneware, glaze

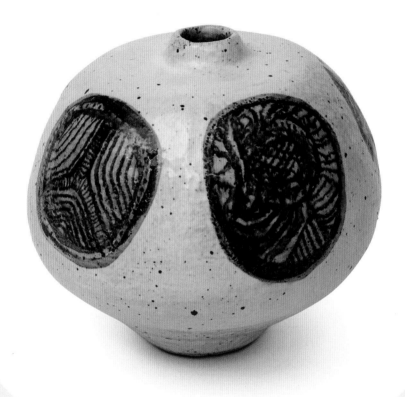

Nine Vessels for Yianna, 2014
Ceramic stoneware, glaze

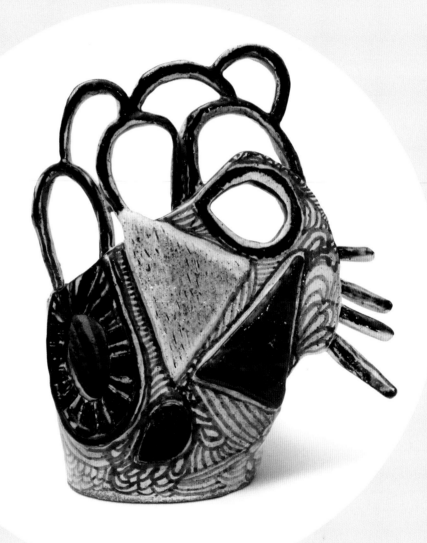

Two Faced, 2013
Ceramic stoneware, glaze

157
KATY KRANTZ

Untitled 5, 2014
Earthenware

MARIA KRISTOFERSSON

BORN

Falköping, Sweden, 1956

CURRENT LOCATION

Götheborg (Gothenburg), Sweden
www.mariakristofersson.se
www.mariakristofersson.blogspot.com

BIOGRAPHY

Maria Kristofersson is a Swedish ceramicist living in Gothenburg. Kristofersson studied painting before taking up ceramics and receiving a Master of Fine Arts in Ceramics from Göteborgs Universitet. She has had solo shows at Galleri Anna H (Gothenburg) in 2014 and at Konsthantverkarna (Karlstad) in 2013. Kristofersson won the Norwegian Sør Villvinpriset prize for ceramics in 2014.

ARTIST STATEMENT

Proximity, distance, fragility, and robustness are important themes for me. Function is always subordinate to the expression of ideas. Clay provides both guidance and resistance, and makes it possible to work in three dimensions. Perhaps because of my background, drawing and painting are the underlying basis of my work in ceramics.

Untitled 3, 2015
Earthenware

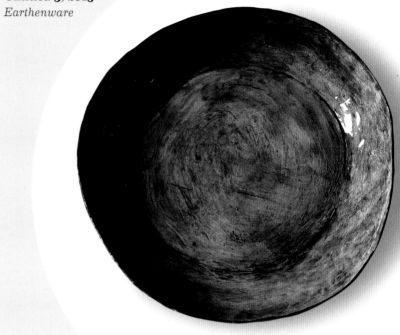

Untitled 6, 2014
Earthenware

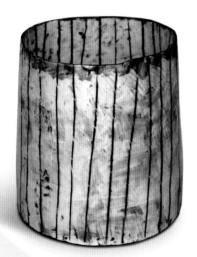

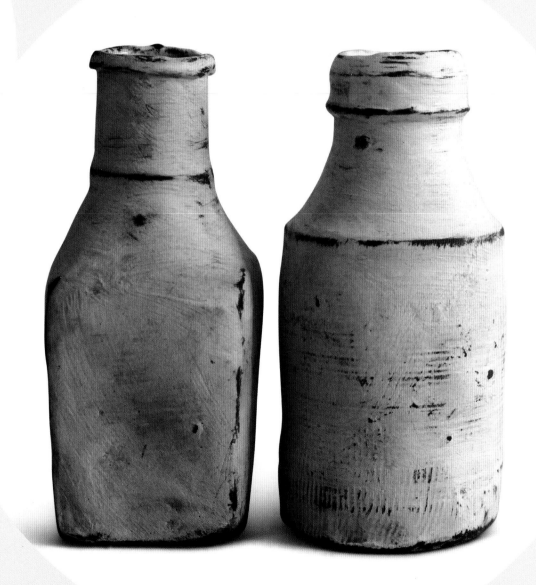

Untitled 4, 2013
Earthenware

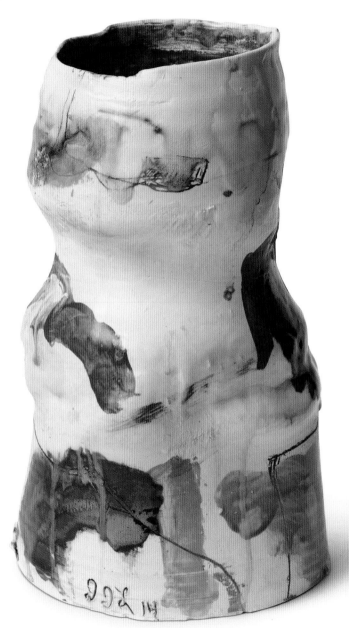

Certain, 2014
Stoneware, glaze

JENNIE JIEUN LEE

BORN

Seoul, Korea, 1973

CURRENT LOCATION

Brooklyn, New York
www.jenniejieunlee.com

BIOGRAPHY

Jennie Jieun Lee was born in Seoul and immigrated to New York at the age of four. In 1999 she graduated from the School of the Museum of Fine Art, Boston, where she studied printmaking and ceramics. After years spent working in the fashion industry, Lee returned to clay and has received a strong response to her expressive, painterly works. Lee spends about half of her time making ceramic art objects and half making tabletop ceramics.

ARTIST STATEMENT

For me, porcelain forms act almost as canvases for my masklike creations. In these abstracted, grotesque works, I use washes of color along with three-dimensional embellishments to add both weight and levity.

Departing from my formal training, I have created a signature experimental style and approach to color, shape, and mark-making. Layered glazes, drips, and pours borrow from painting, while the energy captured in the works speaks to my personal investment in the material, which feels transformed, almost through catharsis, reflecting my personal history.

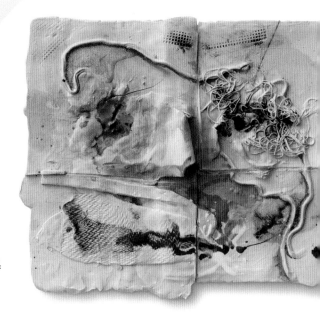

Eating Alone in Many Pizzerias, 2014
Stoneware, glaze

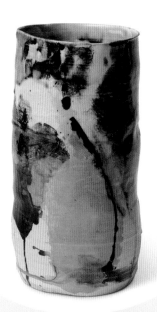

Isolation Gown, 2014
Stoneware, glaze

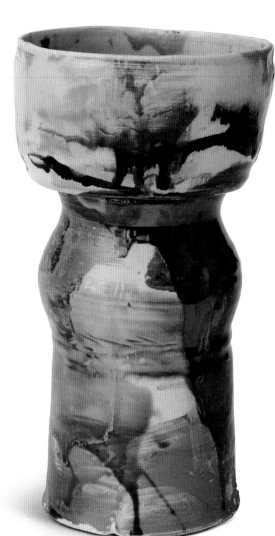

Untitled, 2014
Stoneware, glaze

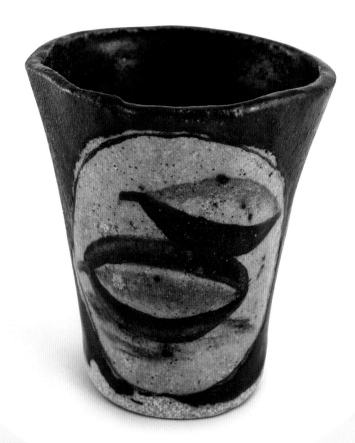

Lotería Watermelon Tumbler, 2014
Clay, underglaze, and glaze

REBEKAH MILES

BORN

Santa Barbara, California, 1976

CURRENT LOCATION

Santa Barbara, California
www.rebekahmiles.com

BIOGRAPHY

Rebekah Miles is a self-taught ceramicist whose vintage-inspired pieces are equal parts painting and ceramics. In 2000 she graduated with a Bachelor of Arts in Studio Art from Scripps College, and in 2006 received a Master of Fine Arts in Studio Art from Portland State University. Her work has appeared in T Magazine, It's Nice That, and purple DIARY. Miles lives in her native Santa Barbara.

ARTIST STATEMENT

I am primarily a painter using clay as my "canvas." Many of my paintings are interpretations of images that appeal to a sense of place and beauty, such as an antique Lotería set from the 1800s, a seed-savers-exchange catalog, and a California native-plant identification book. I want to make beautiful pieces that feel like heirlooms.

Rainbow Trout Dish, 2014
Clay, underglaze, and glaze

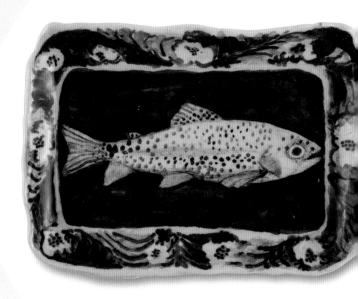

Orange Dish with Verbena Flower, 2014
Clay, colored slip, underglaze, and glaze

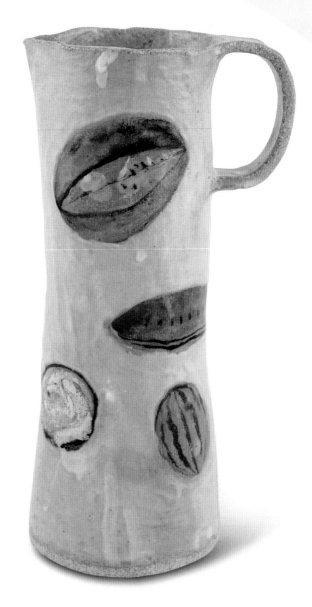

Turquoise Pitcher with Heirloom Watermelons, 2014
Clay, colored slip, underglaze, and glaze

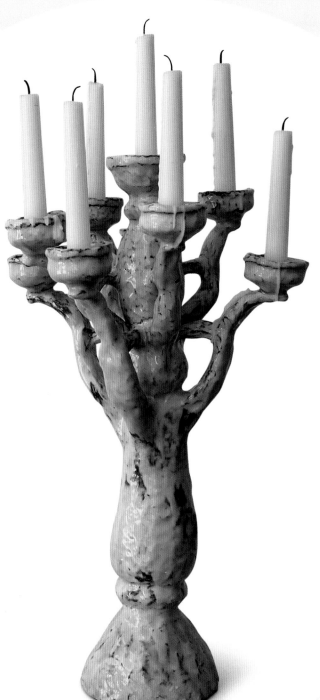

Candelabra, 2012
Earthenware, slip, and glaze

JOANNA POWELL

BORN

Dallas, Texas, 1981

CURRENT LOCATION

Helena, Montana
www.joannapowellstudio.com

BIOGRAPHY

Joanna Powell received a Bachelor of Fine Arts in Ceramics from the University of North Texas in 2008 and a Master of Fine Arts in Ceramics from the University of Colorado at Boulder in 2012. Powell has exhibited her work throughout the United States, including Plinth Gallery (Denver); Showpen Gallery (Denver); and the Society for Contemporary Craft (Pittsburgh), where she was a LEAP finalist in 2011. Powell received Honorable Mention in the Zanesville (Ohio) Prize for Contemporary Ceramics.

ARTIST STATEMENT

I find beauty in my embarrassment.
I welcome the silly.
Through the arrangement of objects, I set up a situation or narrative where the viewer can forget about an object's function, and this calls attention to its possibilities as pure matter with its own intentions. I want to encourage questions about what is happening with the objects, and the peculiar, unclear narratives welcome this conversation. I adore the response clay has to the touch and its ability to record the feeling of a moment. It is a very human material with an incredible history. Clay speaks of an ability to persevere and of permanence and impermanence. I enjoy using all materials, but clay is always present in my practice.

Flower Urns, 2014
Earthenware, majolica, and gold luster

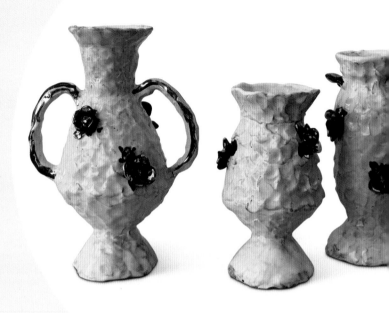

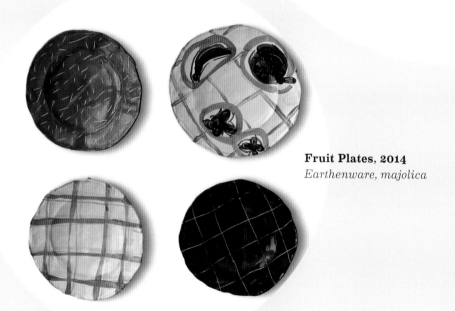

Fruit Plates, 2014
Earthenware, majolica

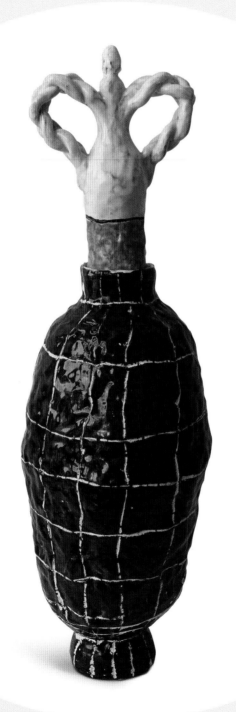

Braided Urn, 2014
Earthenware, majolica

PHOTOGRAPHY CREDITS

Pages 132, 134 (bottom)–135:	ROBERT STORM
Page 134 (top):	FRANCES PALMER
Pages 136–138 (top):	TERRANCE BOGUE
Pages 138 (bottom)–141:	ANDREW BARCHARM
Pages 144–147:	YUULA BENIVOLSKI
Pages 148–151:	BRENDAN TIMMINS & ELYSE DEROSIA
Pages 152–155, 157:	KATY KRANTZ
Page 156:	HEATHER RASMUSSEN
Pages 158–161:	MARIA KRISTOFERSSON
Pages 162–165:	ANDRES RAMIREZ
Pages 166–169:	CARA ROBBINS
Pages 170–173:	JOANNA POWELL